IF YOU CAN
DOODLE
YOU CAN
PAINT

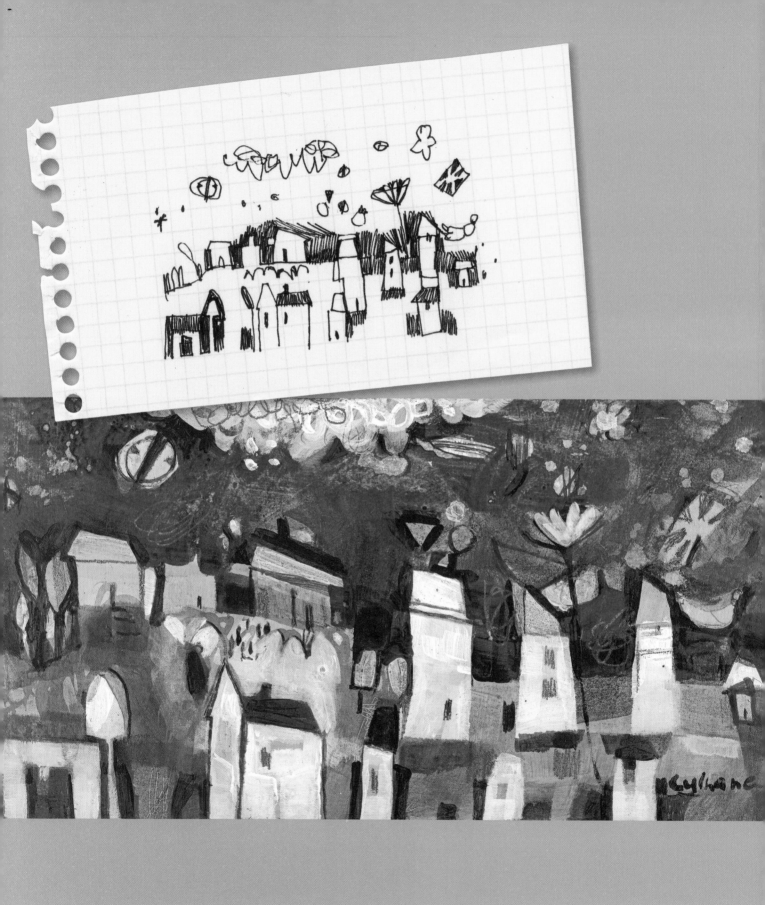

IF YOU CAN DOODLE YOU CAN PAINT

TRANSFORMING SIMPLE DRAWINGS INTO WORKS OF ART

DIANE CULHANE

Photography by Matisse Berthiaume

QUARRY

Inspiring | Educating | Creating | Entertaining

Brimming with creative inspiration, how-to projects, and useful information to enrich your everyday life, Quarto Knows is a favorite destination for those pursuing their interests and passions. Visit our site and dig deeper with our books into your area of interest: Quarto Creates, Quarto Cooks, Quarto Homes, Quarto Lives, Quarto Drives, Quarto Explores, Quarto Gifts, or Quarto Kids.

First published in the United States of America in 2017 by
Quarry Books, an imprint of The Quarto Group,
100 Cummings Center, Suite 265-D, Beverly, MA 01915, USA.
T (978) 282-9590 F (978) 283-2742
QuartoKnows.com

Quarry Books Press titles are also available at discount for retail, whole-sale, promotional, and bulk purchase. For details, contact the Special Sales Manager by email at specialsales@quarto.com or by mail at The Quarto Group, Attn: Special Sales Manager, 401 Second Avenue North, Suite 310, Minneapolis, MN 55401, USA.

10 9 8 7 6 5 4 3 2

ISBN: 978-1-63159-289-8

Library of Congress Cataloging-in-Publication Data

Culhane, Diane, author.
If you can doodle, you can paint : transforming simple drawings into
 works of art / Diane Culhane.
ISBN 9781631592898 (paperback)
1. Art—Technique. 2. Doodles.
N7433 .C85 2017
701/.8—dc23
2016046396

Design: Debbie Berne
Photography: Matisse L. Berthiaume // Matisse LB Photography, except
page 111 image by Bradford Bohonus

Printed in China

This book is dedicated to my dad,
Frank Robert Culhane,
whose nickname was "Doodles Culhane."

This book is written for you. I believe you can make beautiful works of art. Everyone has a creative spark inside that never goes away. It is in the doing. It is pure. It is captivating. Spend time in action. Fuel it. Feel it. Express it. As children, making marks was our first language, even before speech. Given a crayon at a young age, we expressed without restraint. And that is the biggest ingredient for an evocative piece of artwork. Reach into the joy in the making.

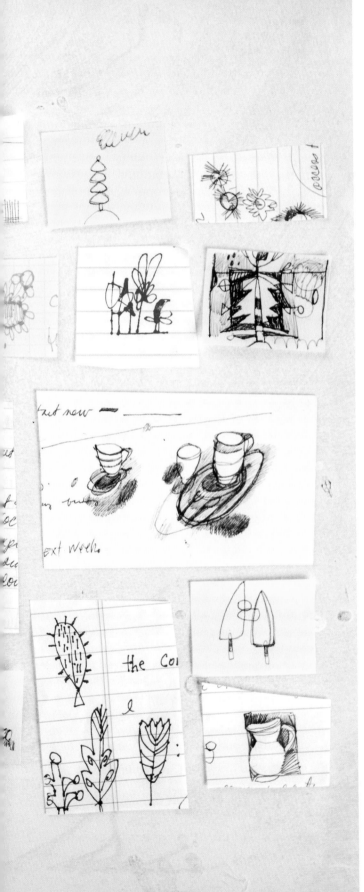

CONTENTS

Introduction .. 8

1 GETTING STARTED 10
Art Supplies and Materials 12
Collecting Doodles ... 14

2 DOODLE SPECIFICS 20
BUILDING YOUR IMAGE LIBRARY
Exercise 1: Line Quality..................................... 22
Exercise 2: Let It Loose: Small, Medium,
and Large Doodling... 24
Exercise 3: Circles and Lines.............................. 34
Exercise 4: Right to Left.................................... 38
Exercise 5: Doodle While Reading 40
Exercise 6: Pick a Theme 42
Exercise 7: Taking a Line for a Walk 50

3 DOODLE COLLECTIONS 54
FOLDED BOOKS AND REVAMPED JOURNAL
Project 1: Folded or Sewn Books 56
Project 2: Revamped Journals............................... 62

4 BLOWING IT UP 68
ENLARGING YOUR DOODLES
Exercise 8: Expanding Imagery with a Copy or Scan.....70
Exercise 9: Adding Color.................................... 73

5 MIXED MEDIA 76
PAINTING WITH YOUR DOODLES
Project 3: Copy Yourself: Hand-Eye Coordination 78
Project 4: Grid Painting..................................... 82
Project 5: Theme Painting 86
Project 6: Abstract Painting: Mixed Media................ 92

6 ARTIST GALLERY 100
About the Author... 111
Acknowledgments .. 112

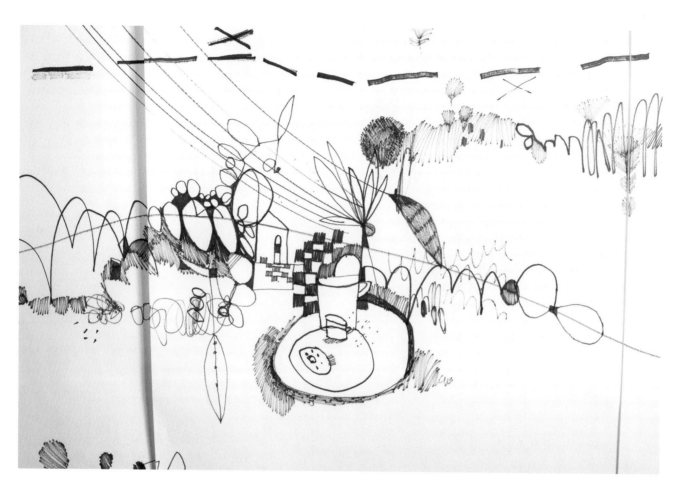

INTRODUCTION

Doodle. It's simple, right? Anyone can doodle. It is just making marks on the page while your mind is busy thinking or listening. Your brain doodles without judgment, without thinking or giving commands, and without expectations about the process. Disengaged from your inner critic, flowing along in the moment, you are present. Like a leaf floating on a moving river, doodling is fully itself and at the same time moving with the current.

Yet the word *doodle* bothers me because it sounds like something insignificant, immature, even trivial.

It does not fully express how important this process is. Doodling cannot be measured. It is a solid world in itself, and it is one of which I am humbly proud. Doodling is your voice spoken on the page, and it will take you places you cannot go alone. It is simple and yet full of complexity.

How can doodling add to your creative arsenal? For me, doodling is intuitive, organic, automatic mark making, where there is no censoring, just doing and discovering. By following its thread, you access inventive shapes and forms, new image combinations,

and design insights. This is the foundational concept for this book—to take that place you find in doodling, where mark making comes naturally, unbidden, and explode it into your creative life.

A doodle is already at your fingertips. It's mark making when you are otherwise occupied, perhaps talking on the phone or listening at a meeting. It is automatic, without deliberate thinking about what is "good" or "bad." It pours out of you easily, from a pure subconscious place, with no agenda for where you are headed. I describe this process as "one mark at a time," and it evolves into a conversation, so to speak, on a two-dimensional surface.

I believe that doodling is a creative source of inspiration for the more serious artwork that comes from thoughtful play and advancement into and inside of your creative life. I am an artist who doodles *all* the time: whenever I have a pen, pencil, or marker and a drawing surface, I am doodling. Always. It is my way of processing information visually, externally or internally, simultaneously or singularly, representationally or figuratively. I literally think on paper. Doodling keeps me connected to my art life and makes me feel as though I am always progressing.

This book is my way of sharing the art of doodling with you. Many of the ideas began with the curriculum for my online class Doings of a Doodle. This book continues to explore the doodle and how it can lead to more mature artwork. The invitation starts with a pencil. You begin with an inquiry or an observation. You simply do what comes naturally—doodling—and then you study your doodles and grow them into a larger piece, adding paint and mixed media. The doodle thus becomes a guide that leads to further decisions about composition and principles of design. Through the step-by-step exercises and projects in this book, a simple doodle is translated into a more comprehensive and unified work, bringing out a style that is authentically you.

Your artistic style comes from deep inside you. It is there waiting, and its purpose is to be fully expressed. Just as your handwriting is uniquely you, so too is the way you touch the paper, the way you move your hand, and the doodles that flow when you are least concerned with making "art." These marks—these doodles—are foundational and powerful when translated and transformed into a larger format. There are treasures embedded within, including your unique voice.

I used to believe that when I shut the studio door, I was making art for me. Now I am learning that art is bigger than that. It's a shared experience. I need to make art for you, too, and we need to make it for each other. Art becomes something bigger and fuller when we all join in. This book is about discovering your fullness as an artist by courageously letting your doodles find their way into larger works. It is a place of creativity, full of potential and an adventure in the making and in the sharing.

I am excited to help you express your artistic self by awakening your creative spirit. I invite you to dig deep into this material. Delight in the process. It might challenge you; it might open doors for you; and it just might show you how incredibly inventive of a human being you already are.

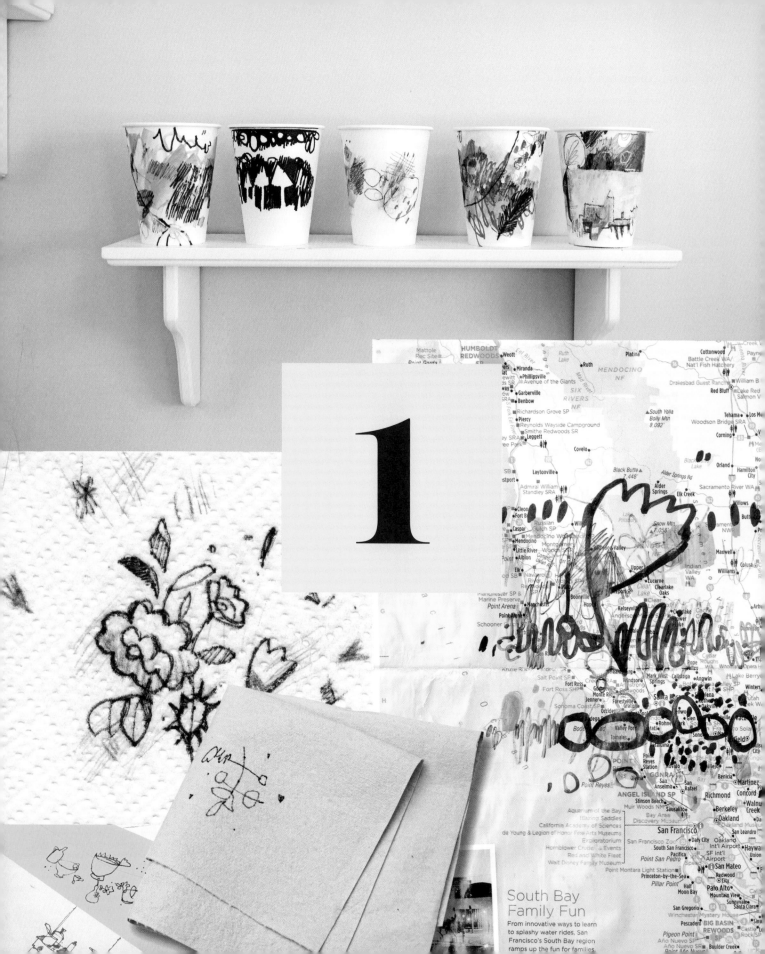

GETTING STARTED

Getting started is as simple as picking up a pencil and paper, but do not be limited by those materials. Try other surfaces and other forms of paper. You can doodle on your jeans or even on a T-shirt!

< Some of the surfaces where doodles can land: paper cups, paper towels, envelopes, maps, old books, and cardboard.

ART SUPPLIES AND MATERIALS

The list of art supplies for doodling is fairly basic, and chances are you already have many of them.

Paper
Drawing paper in any size, printer paper, watercolor paper, Okawara rice paper, cardstock, notebooks, journals, sketchbooks, or scrap paper of any type

Pens
Gel, ballpoint, water-soluble, permanent, all in various colors

Pencils
B (soft) and H (hard) leads

Charcoal
In various types

Markers
Fine and ultra-fine tips; Copic markers, in various colors

Paints
Acrylics, acrylic paint markers

Painting surfaces
Wood panels, canvas

Application tools
Paintbrushes, paint rollers, squeegee, trowels

Textural tools
Sandpaper, scrapers

Adhesives
Glue sticks, blue tape, decorative washi tape, gel medium

Acrylic paint tubes

Acrylic markers

Journals

Copic markers

Brushes

Prismacolor colored pencils

Ultra-fine tip markers

Pencils, pens, and markers

COLLECTING DOODLES

Collecting your doodles means mining your doodle history. Gathering what you already have and what you will continue to create will give you more information to expand upon. Play and explore. Find your favorite marks, the ones that you love, and see if there are images that keep repeating themselves. This reflection will set the stage for things to come.

STEP 1: COLLECT

Treasure hunt. Dig around, as if you are finding diamonds in the rough or nuggets of gold in a stream. Check your piles of papers, journals, to-do lists, bills, and notebooks. Could there be doodles inside books you have read? Look deep into any place or source where you might find an interesting mark on the page. Cut each doodle out, or if you do not want to cut up the page it is on, take a photo of it and print it out. If your hunt does not turn up many doodles, proceed to the exercises in chapter 2 to widen your collection.

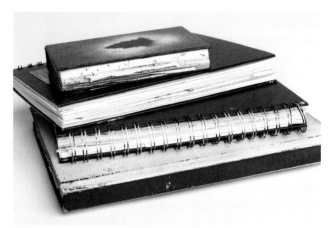

Journals

Lay out your cutout doodles.

STEP 2: OBSERVE

After you have gathered a pile of doodles, arrange them to see how they look with one another. Study them. Soak up the view. Do they relate? Do they fit together? Do they have a dialogue with each other? What is the common thread? Is there a theme that effortlessly emerges when you are doodling without a conscious direction? What recurring images keep coming to the surface?

When looking at a collection of your doodles, delight in the small treasures, just the way they are. Something transformative happens when they are separated from their original contexts. It is as if they are handpicked for something greater. They are full of potential and yet complete just the way they are. Your doodles are really miniature pieces of artwork.

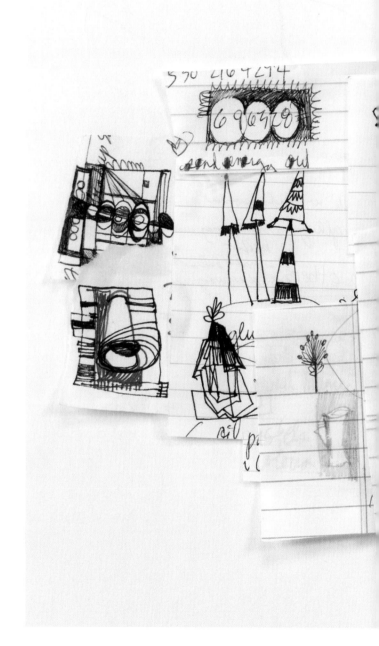

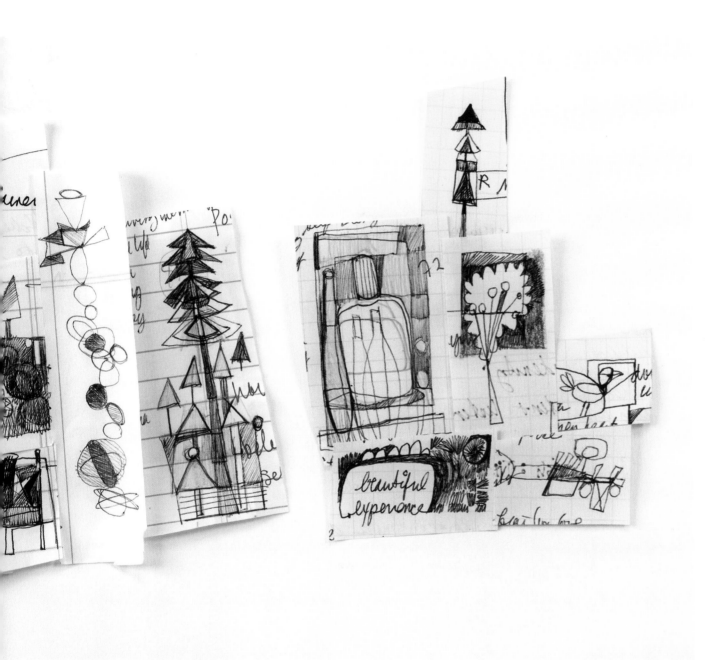

Arrange and study your doodle images.

STEP 3: PRESENT

At this point, you can tape your doodles together as a group or use them individually. Mount them on water-color paper. This framing step provides space around the doodles and elevates their significance. Bring your doodles into a place of importance by taking the time to upgrade their presentation.

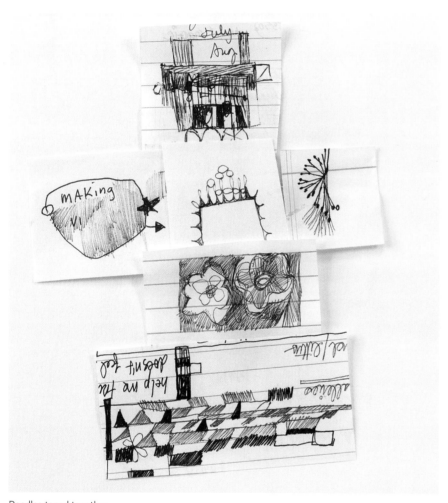

Doodles taped together

Doodles taped onto watercolor paper

2

DOODLE SPECIFICS

Building Your Image Library

There are endless ways to turn the energy inside of you into marks on the page. This chapter outlines several methods of jump-starting your imagery, offering exercises to inspire various types of doodles. Your doodles should be free flowing. They can be directed either by building on particular themes or by creating within certain parameters, large or small.

Exploring these exercises will build your visual vocabulary. Think of your mark making as a dance with the page. The progress of your imagery is like a conversation that will develop as you are engaged in the making. Forms will begin a dialogue with one another; there will be a give and take between the hand movement, the type of mark-making tool, and the type of paper. The beauty is that you do not have to know what you will do next—the process of creating will carry you along. These exercises begin simply and then build while expanding the scope of your artwork.

Start by making marks and see what happens. Allowing yourself to make organic doodles, pure and simple, will show you that there is always a flow of creativity if you open yourself to it. I believe this to be true for everyone. We all have a well of creativity that never runs dry. Sometimes, all you need to do is start. Do not wait for inspiration. Do not wait for a plan. Just experience your creativity by doing and doing and doing. Through the process of creating, discoveries are made and delight arises.

These exercises are like taking a hose and putting different spray nozzles on it: full blast, light spray, wider reach, and so on. Turn on the water by beginning to doodle: start your hand moving and let the creativity flow, just as water flows from a faucet. Whether you make large movements or small ones, take the time to feel and to be present with the page.

1 LINE QUALITY

Let us first turn our attention to line quality. I love lines. I have a romance with them. I spent a whole quarter in college studying line quality. A line is significant and powerful; it is full of expression.

Be aware of lines when you are doodling.

What is the nature of a line? What does a line do? Well, it travels around the surface of the page. By nature, a line is not very wide, though this will vary with the tool used. But the quality of your line must radiate visual energy. The way your chosen implement connects with the paper is a type of dance. The tip of your instrument, the amount of pressure, and the quickness or slowness of your movements all influence line quality.

MATERIALS

mark-making tools

—

various papers

GET STARTED

To study line quality, experiment with different tools. Using a variety of drawing tools and any paper you like, spend time experimenting. As you make marks on various papers, ask yourself how the tool feels when you are in action: Does the ink flow? Does it drag on the page? Are the lines thick or thin, crisp or fuzzy? Notice the paper quality, thickness, and color and how it interacts with the line.

Continue to vary your lines to create interest. The quality of your line will influence your doodles. It is important to pay attention to how you feel when you make various lines, as the lines will carry an energy that others will feel when they see your work. A line radiates something that the viewer can feel. You are the author of that something.

TAKING IT FURTHER

There is an endless variety of lines to explore, with zillions of combinations. As you work through these exercises, one great technique for keeping the flow is to think in opposites. Make thick and thin lines, short and tall lines. Make dotted, dashed, curved, and straight lines. Experiment and play with a range of marks to create more interest in the design.

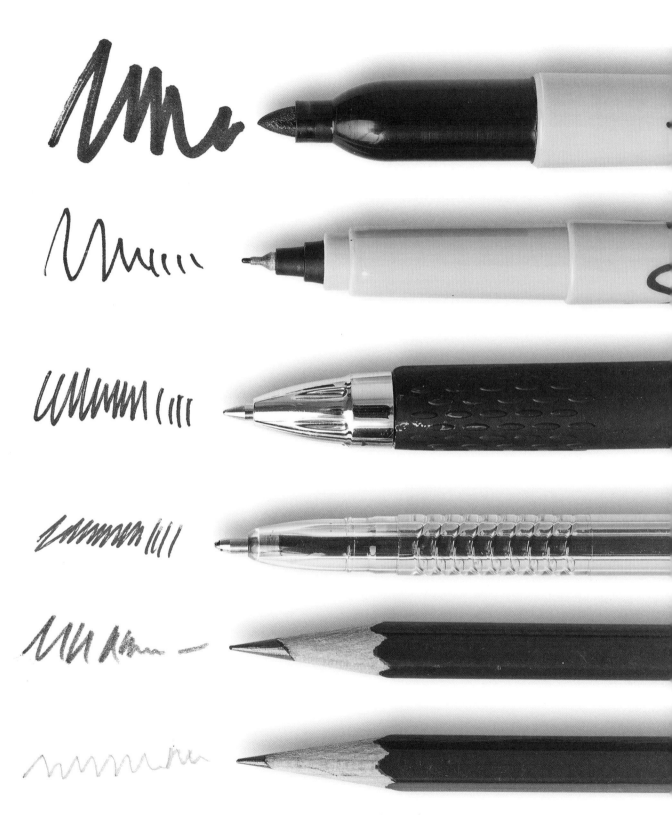

Line quality with various tools: fine tipe marker, ultra fine tip marker, gel pen, ballpoint pen, 2B pencil, H pencil

2 LET IT LOOSE : SMALL, MEDIUM, AND LARGE DOODLING

These exercises will lead you toward a place where you can "let it flow." The key is to find the magical place in the process of making the forms. That flowing place is easiest to find when you are fully present. As we move from practicing small doodles to larger ones, pay attention to the way the movements feel and how the page feels. The way you touch the page with your mark-making tool can evoke emotions for the viewer. The best pieces of art have this evocative component. We feel this when we look at a well-done piece of art—whether it is made by a toddler or a master artist.

Experiment with how you move a mark-making tool and watch how the movement informs the expression. The movement may feel gentle, as if you are touching someone you love, or like rhythmic musical notes, fast or slow or reflective. It may be inspired by deep feelings of sadness or by lightness and delight. When making marks, take the time to feel them and stay present. Record your emotions through the movements.

Start with smaller doodles, just moving your fingers. Work up to medium-size doodles, moving your wrist and forearm. Then jump into the largest doodles you can make, moving your full arm and perhaps even your whole body.

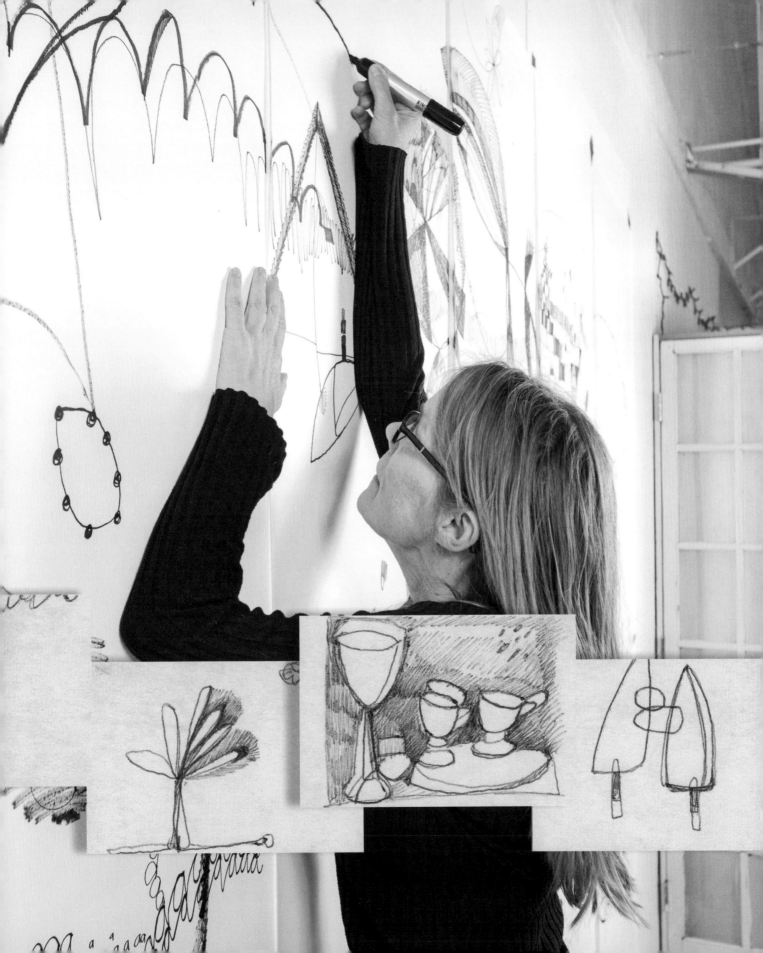

SMALL-SIZE DOODLES:
DRAWING ON STICKY NOTES

In this exercise, we will be moving only our fingers. Be aware of how you hold the pen or pencil and how it informs the line on the paper. Be aware of the area your movements cover. When you move just your fingers, are your marks smaller, contained, precise, or detailed?

GET STARTED

Sticky notes come in the perfect format for small doodle vignettes that can be placed anywhere—on walls, tables, or other sheets of paper. If you prefer, you can cut pieces of paper to 1" (2.5 cm) or 2" (5 cm) squares. The smaller size intentionally limits your range of movements to those generated with the fingers.

Doodle on one sticky note after another. Think back to the marks you've just made and about the ones that will come next. Watch in delight, as if a narrative is unfolding. Let your drawings spill off the page onto your background paper. Your image doesn't have to be confined; think beyond the paper, if you wish!

Small sticky notes

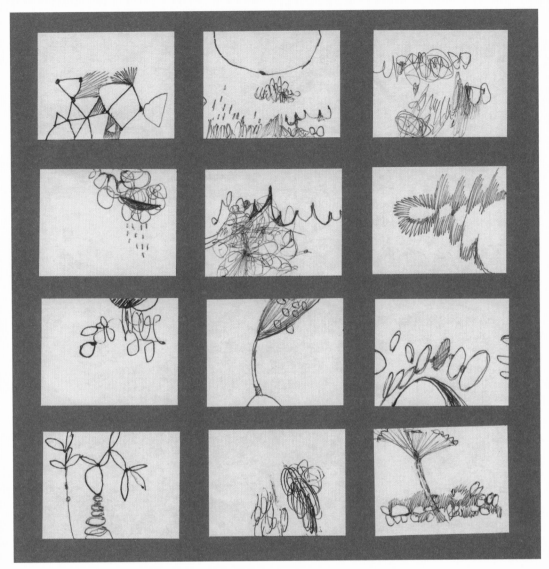

Group of sticky notes
on blue cardstock paper

TAKING IT FURTHER

Once you have a large pile of sticky-note doodle drawings, go back through them and
arrange them into dynamic combinations. The colors of the notes and of the back-
ground paper, as well as the shapes and space in between, will all play a part in the
arrangement. Experiment with placing different arrangements on the wall or on other
flat surfaces. Play with opposites. Alternate busy doodles with quiet ones. Or place sim-
ilar designs side by side. Perhaps you can arrange the doodles like puzzle pieces, so that
the lines from one doodle seem to continue onto other doodles. Later on, use the small
doodles you like best as collage pieces to inform more complex compositions.

Once you find a combination you like, place the sticky notes on a colored sheet of
cardstock. Present them in various ways, in groupings or by themselves. Try posting
them on the wall and stepping back to see how they look together.

WORKING ON SHEETS OF PAPER

This exercise will expand the movements of mark making to include fingers, the hand, the wrist, the forearm, and finally the whole arm. Fill the page with large movements. This will extend the way you interact with the page and make marks. It is a terrific way to make larger works for the projects to come.

GET STARTED

On the first piece of paper, doodle using just finger and hand movements. On the second sheet, start by using your wrist and forearm to make a larger movement. Then, on the third sheet, use your whole arm, moving from right to left, pushing up and pulling down, with the goal of filling the page. Let your marks flow off the page. The extra movement and the disappearing edges will add interest to the line.

MATERIALS

3 sheets of letter size
paper (8½" x 11"
or 21.6 x 28 cm)

—

black marker

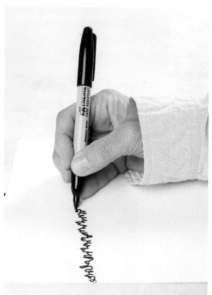

This doodle uses just finger and hand movements.

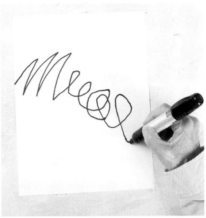

These doodles are drawn using both wrist and forearm movements.

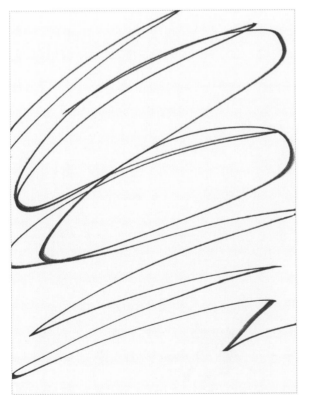

These doodles are drawn using full arm movement.

TAKING IT FURTHER

On a new sheet of paper, create a work that combines finger, hand, wrist, forearm, and full-arm movements.

WORKING ON ROLLS OF PAPER

What do doodles do? So much! Most importantly, they tell a story. Watch what happens when doodling. Maybe you will create a short vignette or one story after another or even a story within a story. The goal of working on a large surface is to draw with your whole body on the largest space you can find until you find a feeling of flow and a place of delight, which happens when you get into a space of expansion and exploration. This can lead to the creation of significant artwork while freeing you from concern about the outcome. Fall in love with the process—the work grows out of the doing. Doodling extra large is a playful adventure. Invite others to join in. Kids love to draw on the wall!

GET STARTED

Begin by taping strips of butcher paper on the wall from the ceiling to the floor. Tape up as many as the space will allow, creating the highest and widest drawing surface possible in anticipation of creating a mural-size piece.

With your choice of mark-making tool in hand, begin drawing with full-body move-ments—reaching up high and walking back and forth. Include lines that move up to the ceiling and back down to the floor. Embrace the beautiful oopses that will happen and enjoy the experiments along the way.

UNLIMITED POSSIBILITIES

- Fill the paper with lines, circles, dashes, dots, triangles, loops, and zigzags. Connect the forms, layering them, and you can also fill them in with colored pencil or markers.

- Listen to music and create a flow. Repeat this exercise. Work on the same sheets of paper over a few days.

- Play with words to express your thinking and feeling processes. Record the internal or shared conversations happening in the moment. Double back and write on top of those words.

MATERIALS

tape

—

butcher paper or craft paper

—

all of your mark-making tools, such as permanent markers, chunky crayons, pens, and pencils

(The piece shown features black markers in several sizes.)

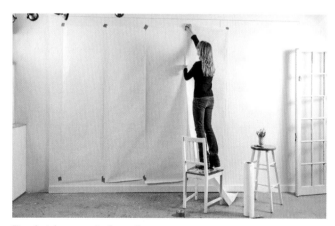

Tape butcher paper to the wall.

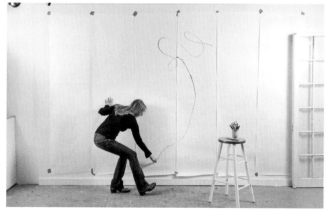

Use your full body to make marks.

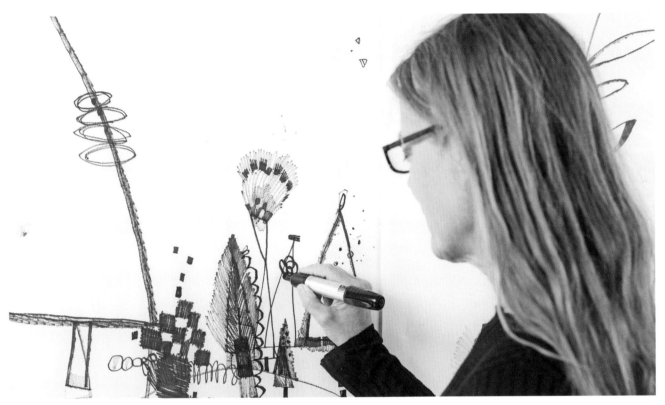

Focus on areas of
interest and details.

- The alphabet is a wonderful source of forms. Draw letter shapes or write in cursive, layering the writing over and over. Or work one letter at a time. Try writing your name again and again—varying the sizes. There are endless ideas to explore!

- Discover how this exercise is a visual story—a record of marks and explorations. It is a free-flowing place to just be and make something meaningful.

TAKING IT FURTHER

When it is time to take down the paper, you can cut the doodles up, save favorite sections, and reassemble the pieces to make new compositions. This leads to further exploration of possibilities for other works of art. First, cut a section into 5" x 5" (13 x 13 cm) pieces and arrange them in a grid. Add color with markers. Move the pieces around, with or without space between each one. Use tape on the back to hold them together. These large drawings will also be useful for collage works. Use them for imaginative projects, including greeting cards, decorative envelopes, and anything else you can think of.

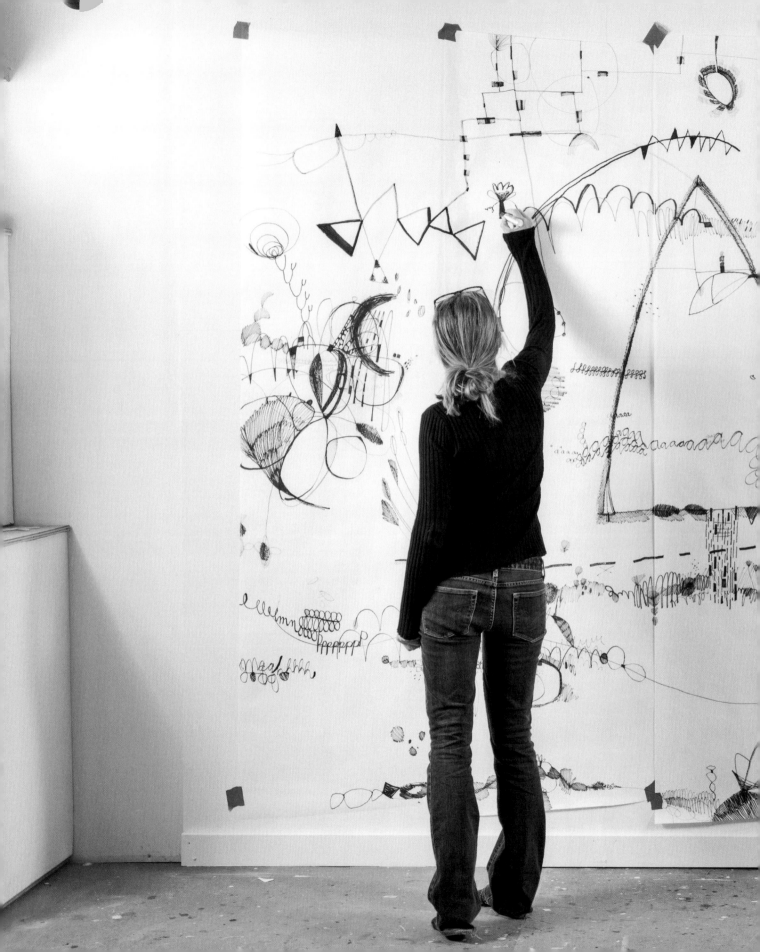

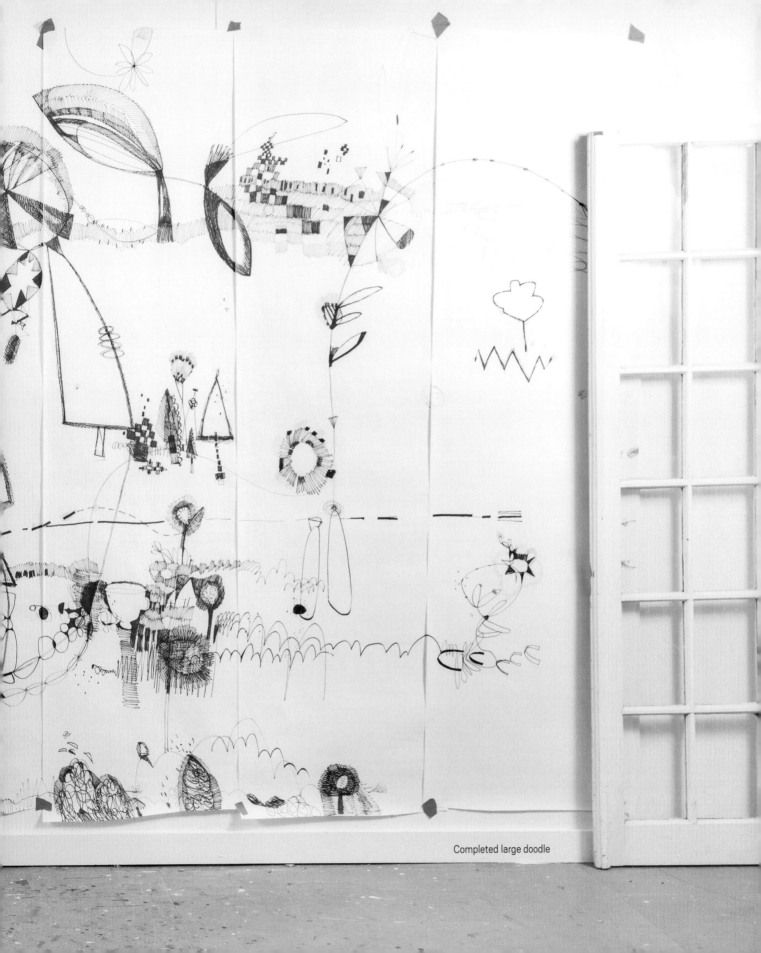

Completed large doodle

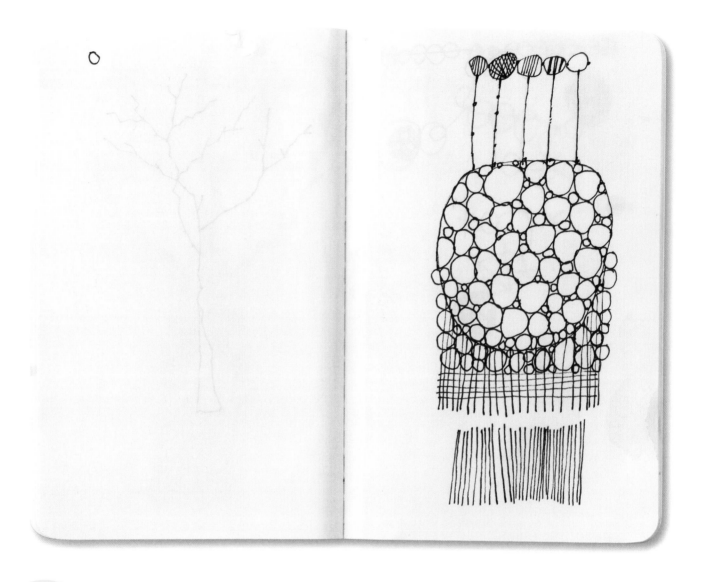

3 CIRCLES AND LINES

The variety and combinations of circles and lines are endless: large, small, short, tall, vertical, horizontal. These simple forms offer a lifetime's worth of exploration. Working with these forms becomes a dance between the movement of the hand and the direction of the tool, creating variation within your page. Watch how the composition builds and grows.

MATERIALS

inexpensive drawing paper in any size

—

mark-making tools: pens, pencils, and markers

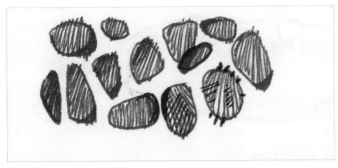

Loosely rendered circles and lines

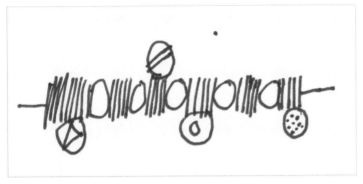

Random circles and lines

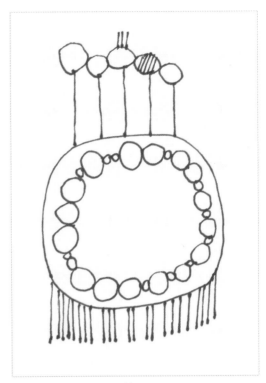

Tightly rendered circles and lines

GET STARTED

Follow your own lead as you explore and discover what is emerging. To begin, draw a random combination of seven circles and seven lines. Next, draw another seven circles and seven lines, all tightly rendered—neat, concise, direct. Finally, draw seven more circles and seven more lines, all loosely rendered—free, messier, not exact, not perfect.

Seven circles and lines

Revisit your compositions and let each doodle grow from its starting place. You can continue with the original pattern or add circles and shapes in contrasting sizes and directions.

Switching mark-making tools can help draw lines that are thick and thin. Create lines that are short and lines that are tall. Place circles and lines inside of circles. Continue to have fun and play with these shapes as they dialogue together.

Composition possibilities with circles and lines

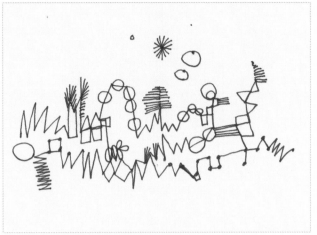

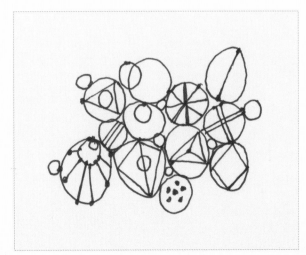

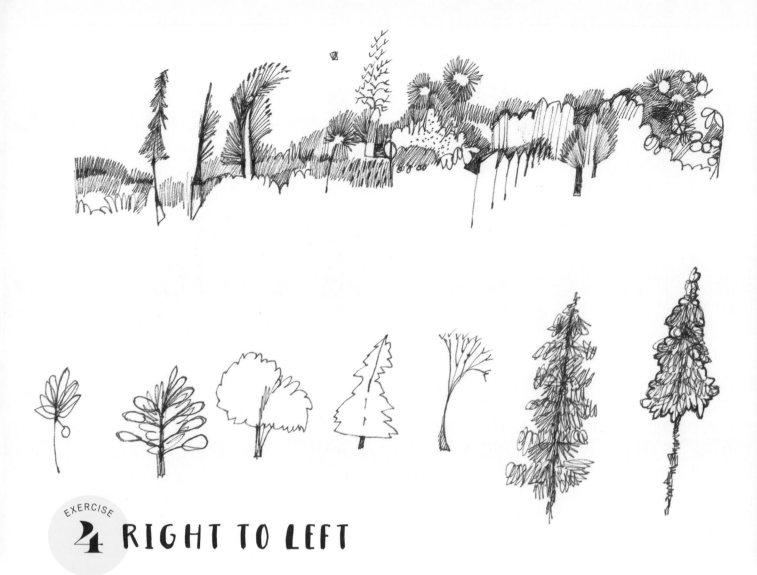

EXERCISE 4 RIGHT TO LEFT

One technique for journaling is to write continuously without lifting the pen, letting your mind step away from conscious planning and thinking. This is what the mind loves to do: engage the creative side of the brain. This exercise is similar, except that instead of journaling with words, we will journal with doodles.

GET STARTED

Start on the left side of the page, as if you were writing a letter. In a continuous unbroken line, move your hand and mark-making tool to the right, then again from left to right. Next, try drawing one continuous line from right to left and then left to right. Repeat. Repeat. Repeat. Watch how the dialogue grows. What changes are happening as you proceed? Are the lines taller or shorter? Do they overlap? What images are appearing and what discoveries are you making? Keep going. Keep going. Keep going. The more you do, the deeper and richer the experience. Treat it like an adventure. What unknown places are waiting to be discovered?

MATERIALS

paper

—

mark-making tool of your choice

—

blank cards and envelopes

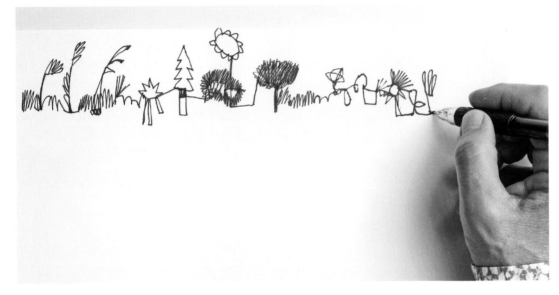

Action image

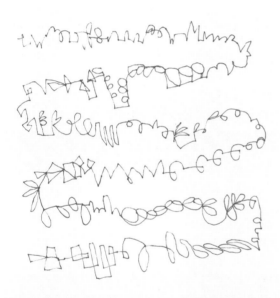

Left to right and right to left

TAKING IT FURTHER

After practicing this image-making technique, you can use the same method to create note cards. Simple, clean lines make delightful greeting cards, and this technique shows off your line making in a presentation that the viewer experiences as a gift. Something tangible and handmade is such a pleasure to receive. To create a card, you can just fold paper to fit into an envelope. If you get on a roll, you can purchase ready-made blank cards that will give your line making a professional look and feel.

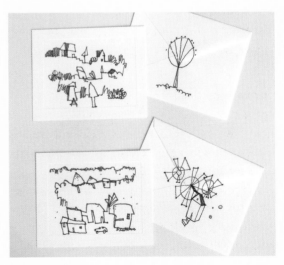

Greeting cards

5 DOODLE WHILE READING

This is like a "blind doodle" exercise, but it requires more than just not looking at the page while making marks. Here you will read while doodling on the page. You can start on the left side of the page and move to the right and see what opens up as you get started, or you can jump around the page. Your marks will come from your mind's active engagement in reading.

MATERIALS

a good book

—

a comfy reading place,
with room for making
marks on the page

—

paper and pencil or
doodle materials
of your choice

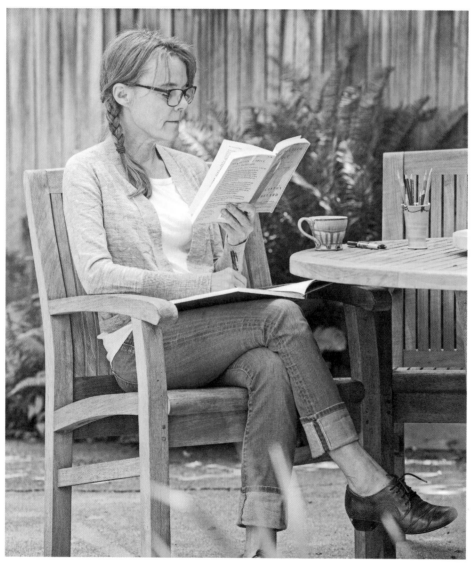

Doodling while reading

GET STARTED

Find a really good book and a place where you can read comfortably with enough room on the side to place a page or pad for doodling. Doodle as you read. Do not be concerned about the outcome. How does this exercise feel? What type of rhythm are you finding? How does this activity broaden or constrict your marks? Do you find that the reading and imagery from the story contribute to the types of lines created, or are they distracting? How does your mind work when you are reading and have your hand moving? Are the results similar to doodles you have made in other situations?

I found doing these two activities distracting at first. I was not able to focus on one or the other. What emerged, however, was a confidence in my ability to multitask. Like breathing, blinking, and all the other things my body does so beautifully to keep me alive, doodling can be fully automated. I willed myself to keep moving my hand on the page while reading a story because I thought it could open up a new level of awareness. Curiosity kept me on task, and I wondered how the reading might contribute to the doodle. I got into it and loosened up as I went along. So much of learning is an actively engaging process, but this worked without my conscious focus. I found that if, while reading, I pushed harder on the mark-making tool and leaned physically into the page, the flow started to happen more easily. For those like me who love to read and to doodle, doing both at the same time is a total win.

Doodling while reading: over-the-shoulder view

TAKING IT FURTHER

When you read, do you visualize the story as it unfolds? If so, what does that look like in your mind's eye? Doodle this. What you discover may astound you. If you do not visualize while you read, doodle to express the words or just make marks with a new rhythm you find from your reading. You may find new content for your doodles that could connect with a larger work.

Final doodle

6 PICK A THEME

This is a directed doodle exercise with a chosen theme. Objects and their shapes are compelling. Think of a theme as a foundation to let free-flowing images inform specific combinations of shapes. Allow your forms to take on a personality. Your doodle does not have to be a realistic representation of the theme. Through this exercise, your personal voice and style will come to life in your rendering of the theme. Give the doodle character by varying the line quality. To make thick and thin lines, alternate between a soft touch and a heavy touch.

MATERIALS

paper of any size

—

mark-making tools

GET STARTED

Prepare several sheets of drawing paper and a range of marking tools. If you wish to use reference material, gather some images of items on the lists that follow. But remember: the point is not to render an accurate representation—only to be inspired by realistic forms. Take liberties and be creative with your doodle drawing.

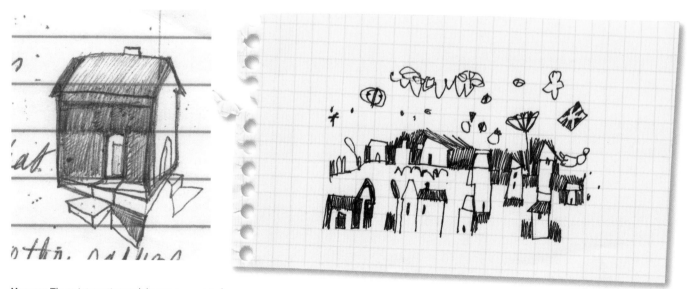

Houses: These interesting and diverse geometric forms are everywhere in a multitude of styles. Houses are so central to our lives, reflecting how we live, move, and have our being.

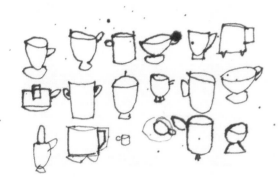

Cups: I love drawing cups and mugs. As you draw, think about how they look and how they feel when you hold them as well as about their function. Coffee culture has us drinking out of paper cups most of the time, but the shape of a handmade ceramic mug is so compelling to use and to draw.

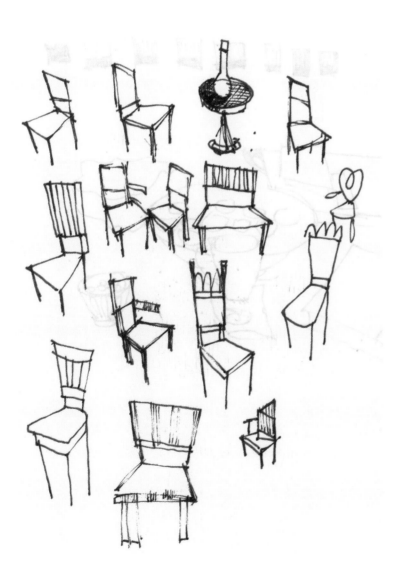

Chairs: Chairs are a visual invitation to come, sit, rest. From basic to ornate, there are so many different types of chairs. There is something intriguing about the spatial relationships and the practical function of a chair.

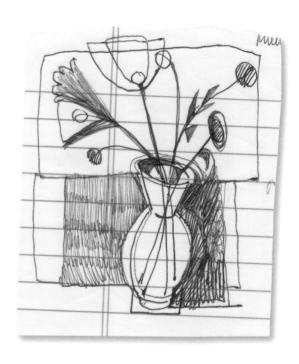

Flowers: Flowers are one of the best of all of nature's living forms, coming in endless shapes and sizes with remarkable combinations of stems and leaves. They delight and greet you as you walk by. They light up our rooms, our gardens, and our seasons.

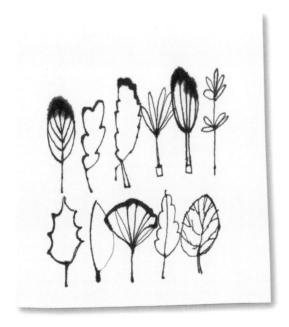

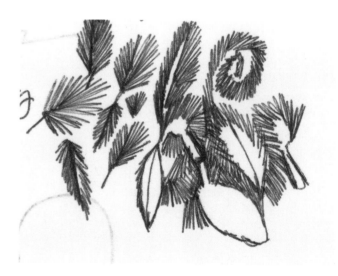

Leaves: Leaves are a wonderful source of drawing material with their variety of shapes and sizes. Study them; collect them. Draw upon what they feel like, whether green and fresh or curling up as they fall and fade.

Animals: Animals exist all around us, making our lives richer. They are friends who enrich our days. Whether familiar pets or exotic wildlife, their forms and features amaze and delight. Their huge variety of shapes and sizes offers a rich source of material for doodling.

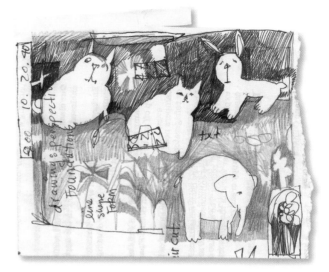

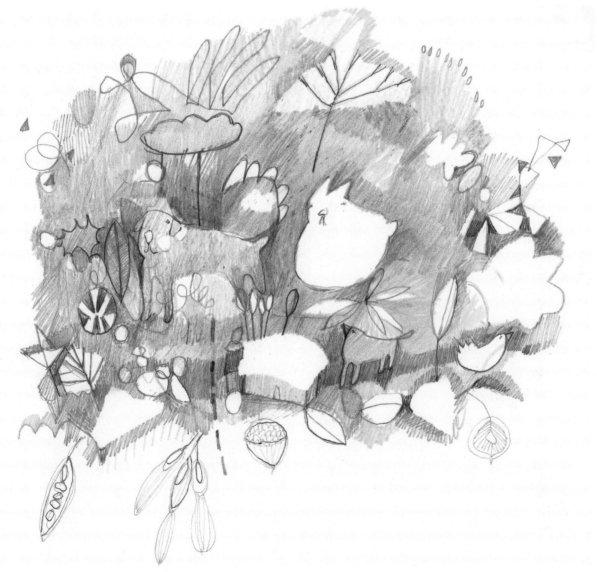

Landscapes: Landscapes are the beauty of the earth. We all have seen a landscape that was so spectacular we stored it in our minds. Draw upon the memories and doodle from that place, making it up as you go.

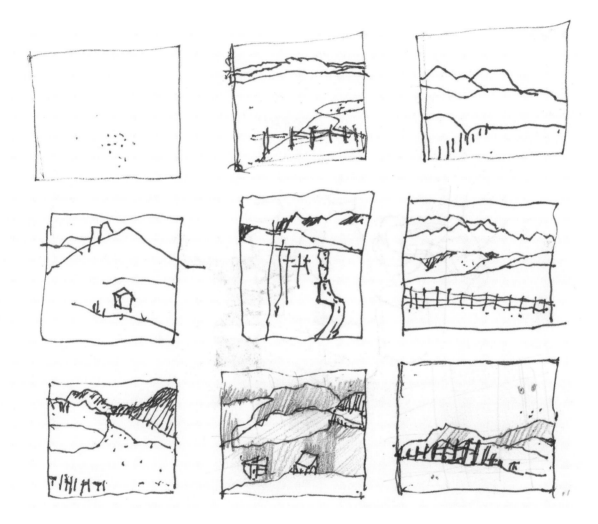

Scenery while riding in a car: Entertain yourself by doodling while riding in a car. Various subjects fly by the car window—sort of like a movie, except it is real life in motion. Observe your surroundings: What is interesting? What would make a good photograph? Instead of snapping an image, record what you see on paper in line and form. Doodling while on vacation is an excellent way of recording your journey as you travel.

Trees: What is not to love about a tree? In all of their seasons of change, trees offer architectural grandeur, organic patterns, dynamic forms, and detailed textures.

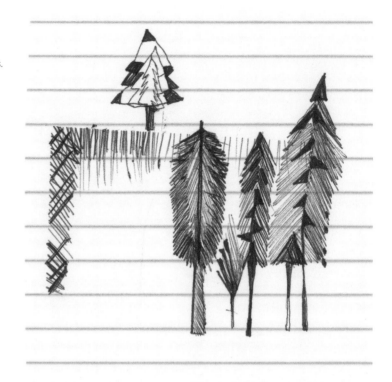

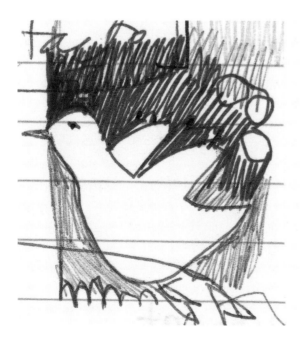

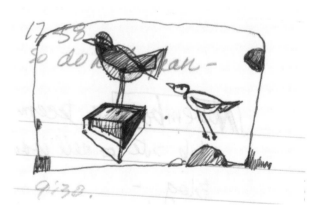

Birds: Birds are everywhere. They surround us on a daily basis if we take the time to notice. These magnificent creatures do not hold still for very long, so to get a better sense of their shapes, spend time looking at bird photos. Visual research is an excellent way to digest and synthesize images to keep in your visual library. Studying objects will allow you to draw upon this vocabulary later in your work.

TAKING IT FURTHER

Abstract: This category of nonrepresentational images is all about the purity of mark making. Anything goes. You have total freedom. Just have fun with it.

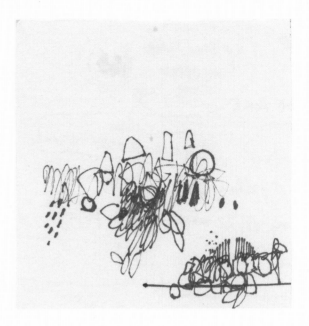

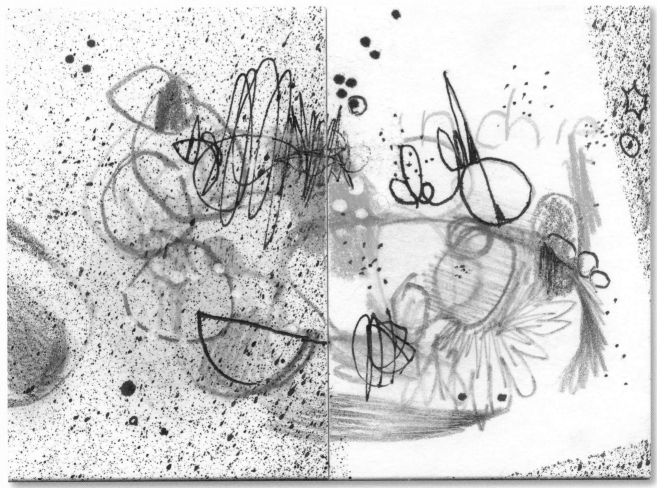

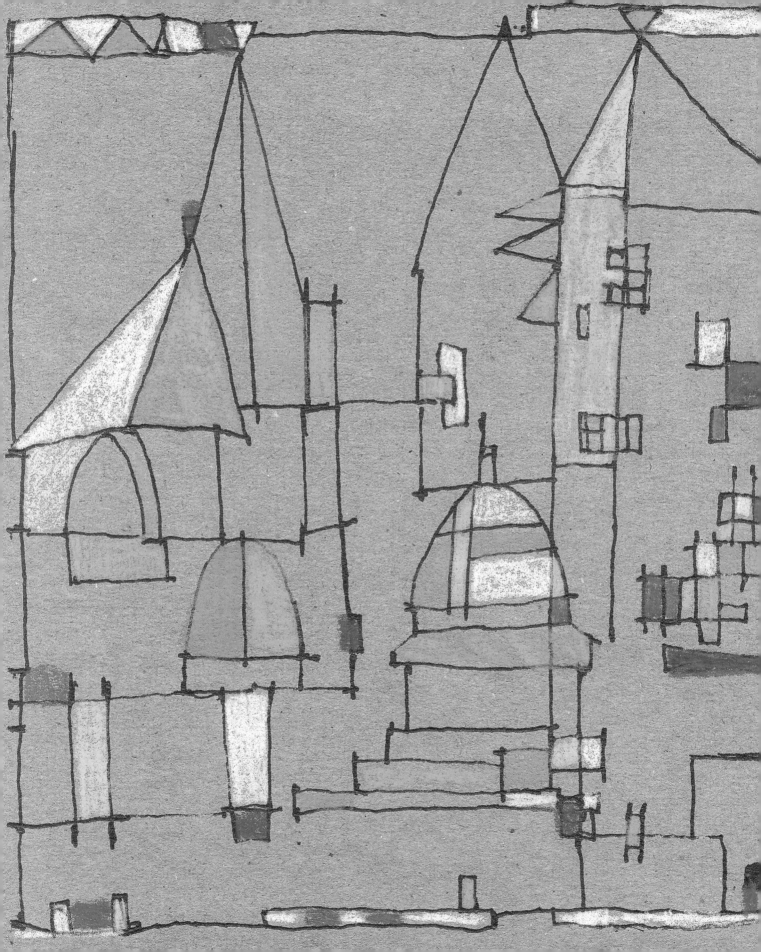

7 TAKING A LINE FOR A WALK

It is all about play. "Taking a line for a walk" is artist Paul Klee's description of creating with a line on a two-dimensional surface. He embodied the utmost adventure in his art and explorations, visually opening up a creative pathway for his and others' artistic inventions. His legacy to us is a visual feast of delight mixed with playfulness.

This exercise is inspired by Paul Klee's work. It is a simple formula for creative invention using line and color. You'll start by walking a line all around the page, and then add color with colored pencils. It is that easy. You will be delighted with your results: all forms and shapes are made from combinations of straight and curved lines, and the possibilities are endless. I have divided this process into two parts: the first uses straight lines with angles and the second uses straight lines with organic curves. Take a line for a walk and mix it up—short and tall, large and small, or other pairs of opposites. See where your line takes you!

GET STARTED

Start with a black gel pen on brown paper. Using just straight lines and angles, travel along the paper. Fill up the page, but leave some open spaces in your design. The open spaces will allow the viewer to focus on the design without it feeling too crowded. Fill places and spaces with the colored pencils. I do not fill in all the shapes with color, because I feel it strengthens the design to leave some areas empty. Sometimes less is more. Experiment with this and see what you find. Keep in mind that this could lead you into a design for a painting.

MATERIALS

black gel pen or
fine-tip marker

—

brown paper (grocery
store paper bag or
brown butcher paper)

—

colored pencils
(I prefer Prismacolor)

—

colored sheet of paper

< Final drawing with straight lines and angles

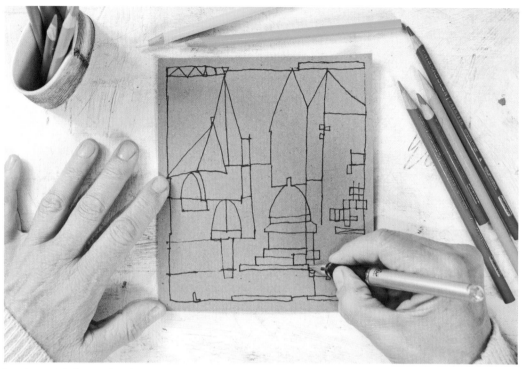

Drawing straight lines and angles

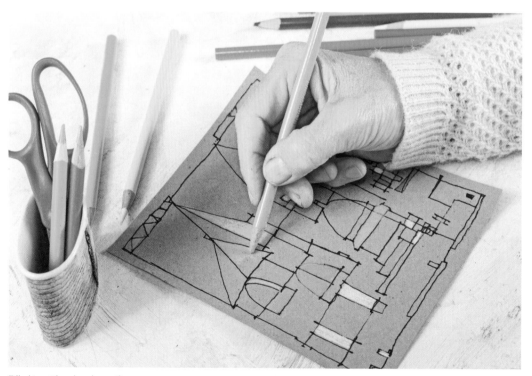

Filled in with colored pencil

IF YOU CAN DOODLE, YOU CAN PAINT

To continue the exercise, use a colored marker on brown paper. This time, use straight lines and curved organic shapes only. Travel with the marker along the paper. Fill in some shapes with colored pencils. How does this piece differ in composition and design from the first one? Adhere the composition to a colored sheet of paper for presentation, if desired.

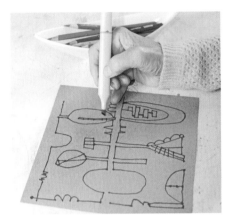

Drawing organic shapes and straight lines

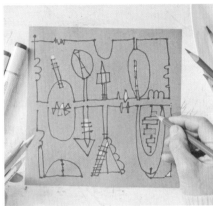

Organic shapes and straight lines filled in with colored pencil

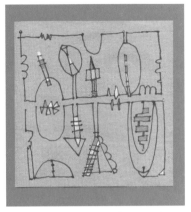

Final drawing with organic shapes and straight lines

TAKING IT FURTHER

Try using different colored sheets of paper. The color of paper you choose affects the colors you put on top of it, as the bottom color will shine through.

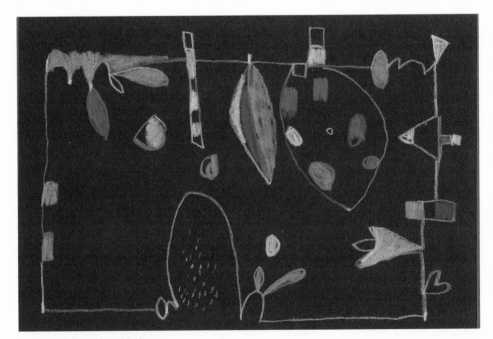

Light-colored pencils on black paper

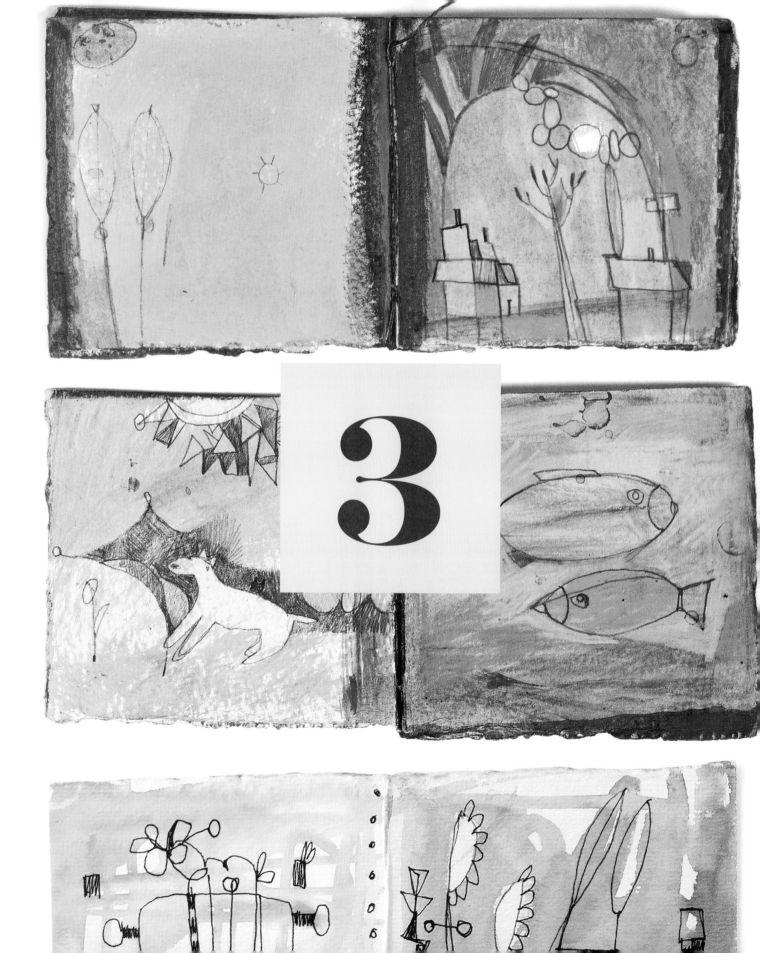

3

DOODLE COLLECTIONS

Folded Books and
Revamped Journals

This chapter will up your doodle game by first preparing the paper ahead of time with some texture and color. This allows the paper to feel more interesting and look more dynamic. Working on the textured, colored surfaces with pencils, ballpoint and gel pens, markers, and colored pencils starts the transition to working on canvas and wood panels. Collage pieces can be added to the surface as well.

The wonderful thing about these doodles is that they will gather and store the moments in your day. They will reveal themselves as recorded memories in a way that a smartphone picture never can. The images record your creativity and what is happening in your life. I call mine Look Books. Think of making these as a gift to your doodle art and a way to set yourself up for your next artistic success.

The first project uses watercolor paper to make a folded book. The second uses old journals, covering what is already there with a thin layer of gesso. These projects will get your pages ready for moments of doodling. By preparing the paper surfaces ahead of time, you create a backdrop for the beauty of your mark making. Covering the paper with a foundational layer of paint creates another dimension of interest and texture. Keep these doodle-ready pages handy for when the need to doodle strikes.

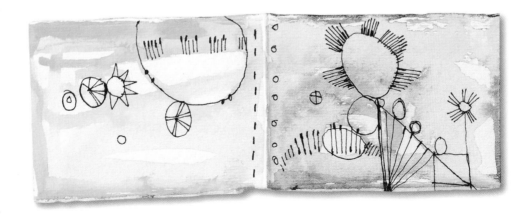

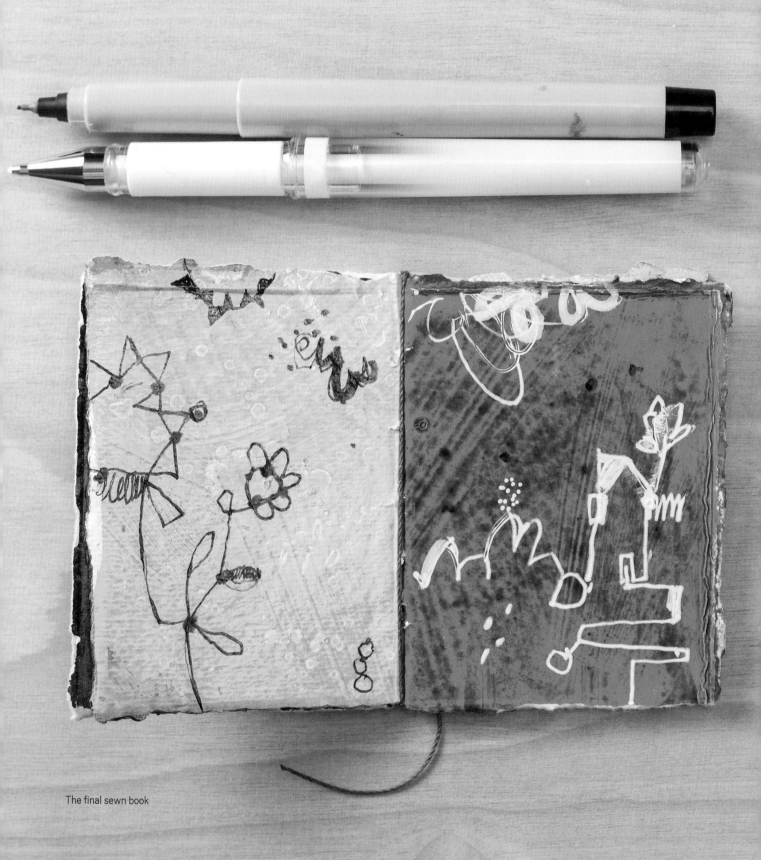

The final sewn book

1 FOLDED OR SEWN BOOKS

I love little things. They are treasures that can be easily held and stored in nooks and crannies. There is nothing better than making a little book with pages that are sewn together or folded into one another (no need to bind them). These small painted books are handy when a doodle attack comes on. Store them in your pocket or bag for easy access. Be sure to also keep various pens or markers around so you will have a variety of tools to choose from while doodling. If your paper has a dark background, use a light or white pen. If the background is light, use a dark or black pen. These value contrasts make for a more dynamic doodle and create interest for the viewer. I used three folded pages, but you can use as many as you want.

MATERIALS

white gesso
(not necessary if using
watercolor paints)

—

paintbrushes

—

watercolor paper

—

acrylic paints

—

ruler

—

scissors or straightedge
for tearing the paper

—

needle and thread,
stapler, or tape

—

script brush

—

Molotow white marker
or markers of choice

—

colored pencils

White line on top of dark background

Variation of a complete book page

Step 1. Apply gesso with a paintbrush to both sides of a sheet of watercolor paper. This seals the surfaces and gets them ready for acrylic paints to be brushed on top. Applying the gesso with a brush also gives the surface a brushstroke texture.

Step 2. Start with bright, warm colors of acrylic paint and cover both sides of the paper. This makes a great background for the darker markers we will be using. Next, cover another page with cool colors of paint, making a background for light-colored markers. Let dry.

Step 3. After the paint dries, decide what size pages you want for your book and then double the length, because you will be folding the pages in half. Any size works well for doodling. Making a larger folded book, such as 6" x 6" (15 x 15 cm), which will be 6" x 12" (15 x 30.5 cm) before folding, will give you some wiggle room. For small folded books, I like a sheet that is 3" x 4½" (7.5 x 11.5 cm), or 3" x 9" (7.5 x 23 cm) before folding. After measuring out the pages on your watercolor paper, cut or tear the edges. A cut edge is clean and precise; a torn edge is a little bit raggedy and has a less refined look. To tear the edge, fold the paper first to get a really good crease. Place a straightedge on the crease and pull up on the paper to tear along the edge. I love a torn edge, as it produces a beautiful presentation. Either method works well for the finished pages of the folded or sewn book.

Step 4. Fold the pages in half and nest them together. You can sew the pages together along the spine or staple or tape them. Sometimes I just fold them into one another without binding them.

Step 5. Now you are ready to doodle to your heart's content. On a warm or lighter background color, use a dark-colored line. On a cool or darker background, use a light-colored line.

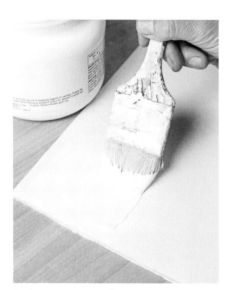

Apply gesso to watercolor paper.

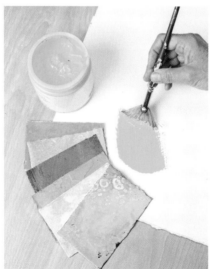

Warm colors

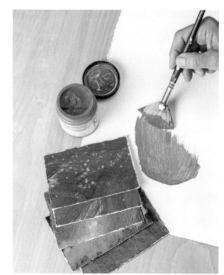

Cool colors

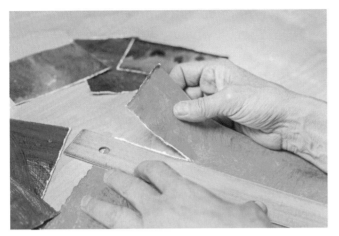

Torn edges

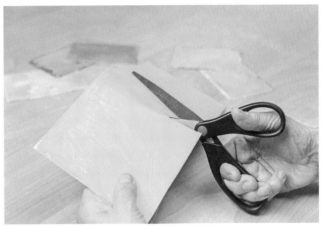

Cut edges

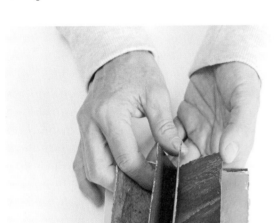

Fold the pages into one another.

Sew the pages together.

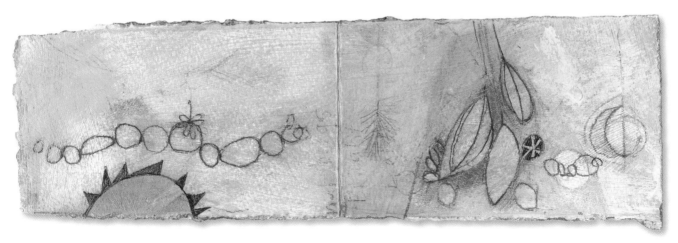

Dark line on top of warm-colored background

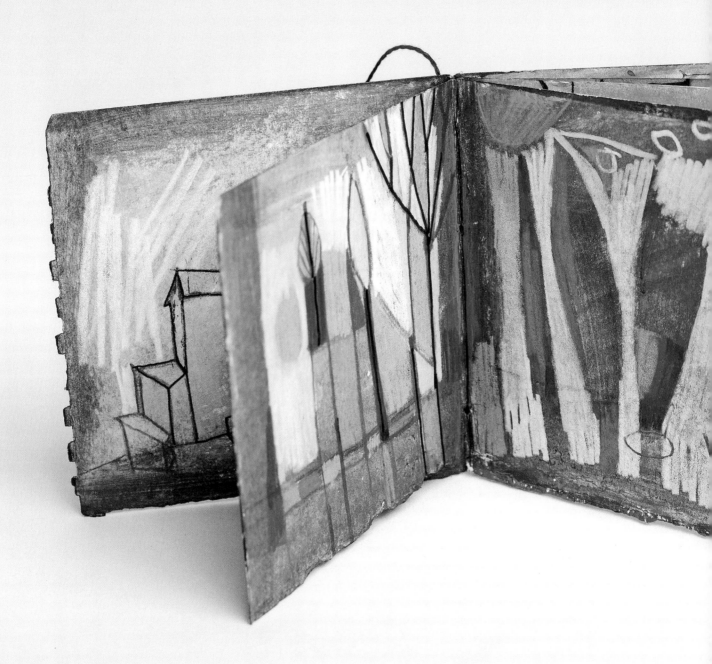

Filling in with colored pencils

TAKING IT FURTHER

You can also use watercolor. If you do, you do not need to gesso the paper. Let the watercolor paint flow from your brush as if it were a marker or pen.

Using the tip of a watercolor brush to doodle on ungessoed paper

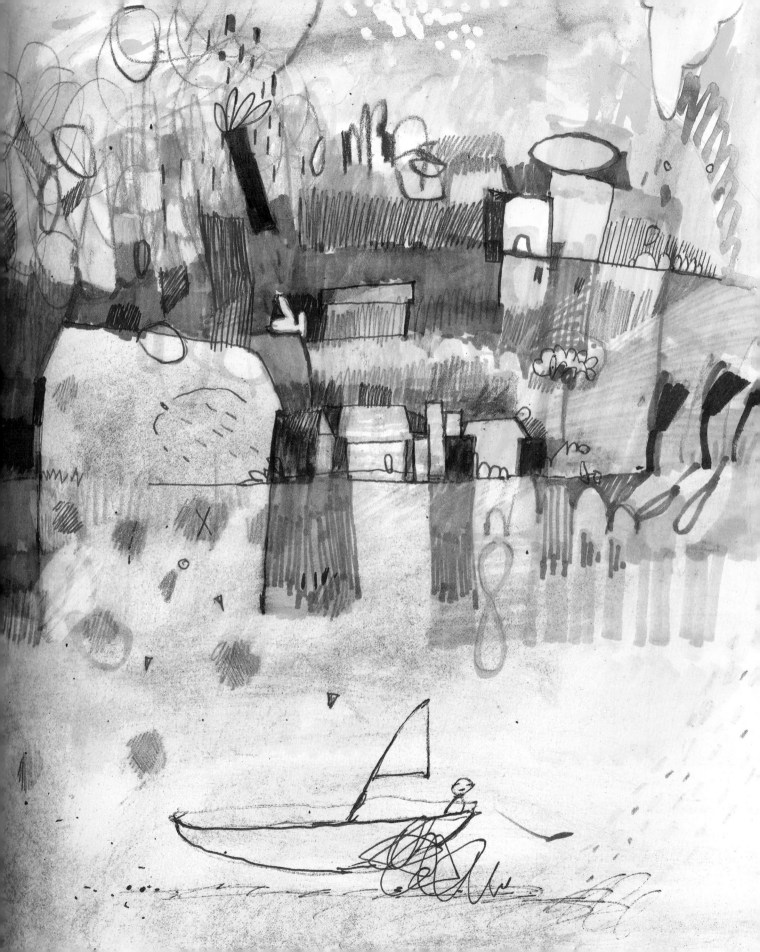

2 REVAMPED JOURNALS

I have a buketload of journals in my closet, with weeks and months of words written on them. They all started with the morning pages championed by Julia Cameron, author of *The Artist's Way.* Her brilliant suggestion of writing three pages every morning is a sort of mind dump to spin you out into your day. This activity over the days morphed into recording years of events, thoughts, and the emotions of living. So, instead of buying new sketchbooks, I decided to recycle these old journals, cover the pages with gesso, and make them into doodle sketchbooks. The writing underneath immediately brings layers to the composition, which creates visual texture. Applying a whisper-thin layer of gesso allows what is underneath to be seen; a thick layer of gesso will cover everything completely. Working on layered pages like these builds a dialogue with what is already on the page. Doodling on them is similar to the process of adding layers of paint to a canvas. Adding and subtracting, layering and covering up, creates interest on the surface and will take your doodles to the next level.

I work on the journal upside down, so the meaning of the writing becomes secondary to the image that is being drawn on top. This adds a sense of mystery to what has been written, because you cannot easily read what is underneath the gessoed layer. Gesso comes in various colors; I like white and gray. I also like to stain some of the pages with used tea bags and wet coffee grounds.

MATERIALS

old journal

—

white and gray gesso

—

used tea bags

—

wet, used coffee grounds

—

acrylic paints

—

soft charcoal

—

paintbrushes

—

ink rollers

—

India ink

—

spray bottle (optional)

—

old credit card

—

pens

—

pencils

—

markers

—

stencils

—

collage materials

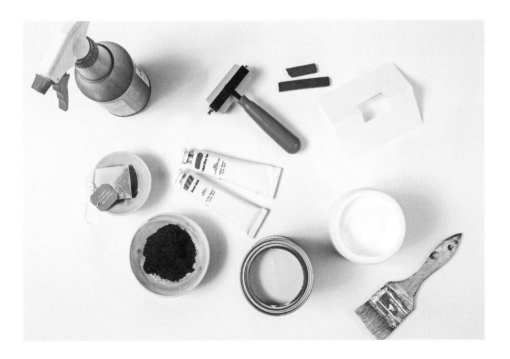

Step 1. Alter the pages of the journal, switching between gesso, tea bags, coffee grounds, paint, and charcoal. Apply with paintbrushes and ink rollers. Add splashes of slightly watered-down India ink or put the ink in a spray bottle and spritz on the pages. Smooth out the surface with an old credit card. Let dry.

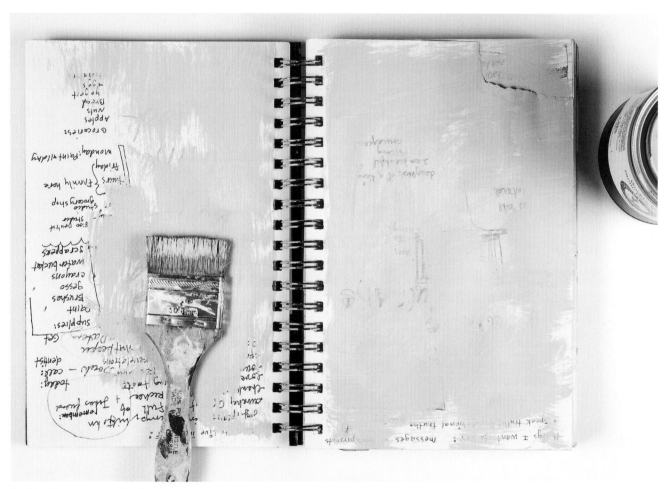

Applying the gray gesso with a brush

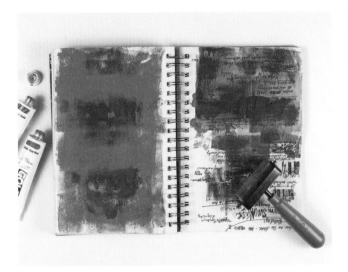

Applying acrylic paints with an ink roller

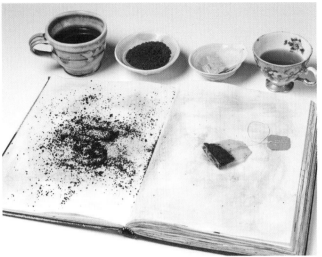

Staining the pages with tea and coffee

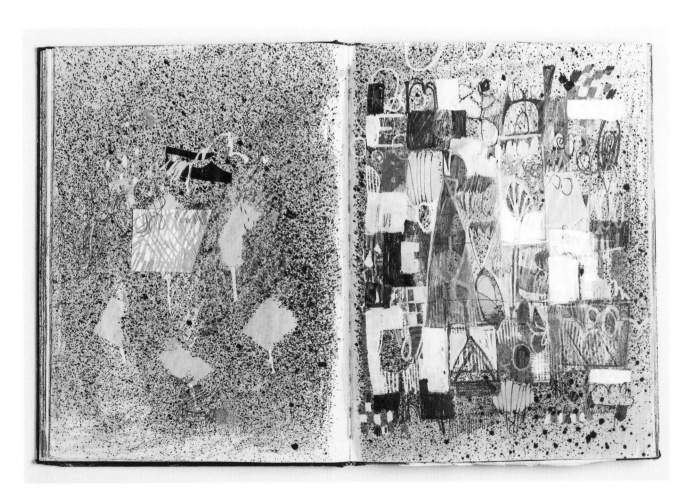

Pages splashed with India ink with doodles.

Step 2. Create compositions with various mark-making tools. Let is flow as you go. Use pens, pencils, markers, stencils, collage papers, and anything else you can think of.

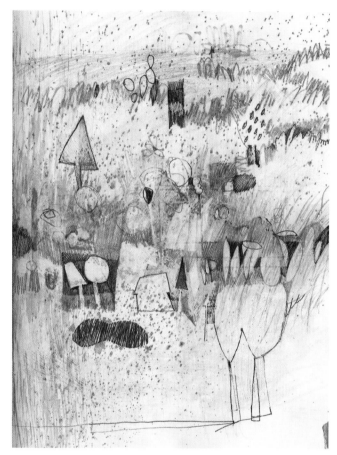

Pens, pencils, markers, light spray of India ink with tea stains

Stencil with pen ink and colored pencils on top of coffee stains

Spray paint with doodling on top

Alphabet letters

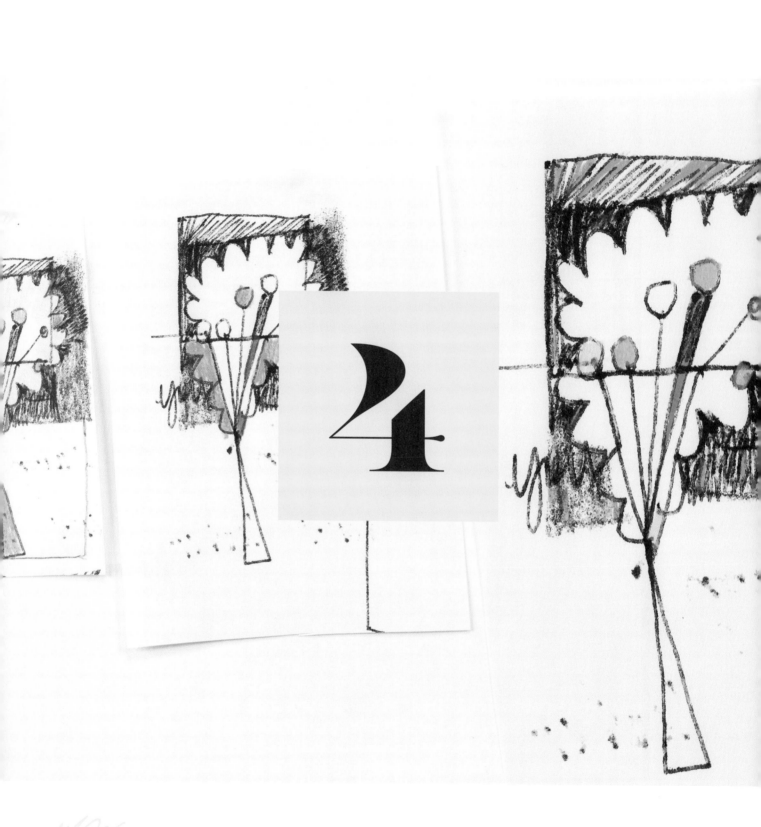

IF YOU CAN DOODLE, YOU CAN PAINT

BLOWING IT UP

Enlarging Your Doodles

A doodle is usually small and done quickly, creating a sense of intimate space. It feels like a hug; it is a space that holds me. I had become very comfortable doing small doodles and I did not know how to go bigger: the larger movements and larger paper felt so different from the smaller space I knew so well. I have since discovered ways to go big and feel comfortable with a space that is really huge in comparison to what I was used to at first. This chapter is designed to guide you into seeing your work enlarged without much effort, along with adding color and creating a final presentation. These exercises will help you take the next steps with your doodles as they grow in an expansive way.

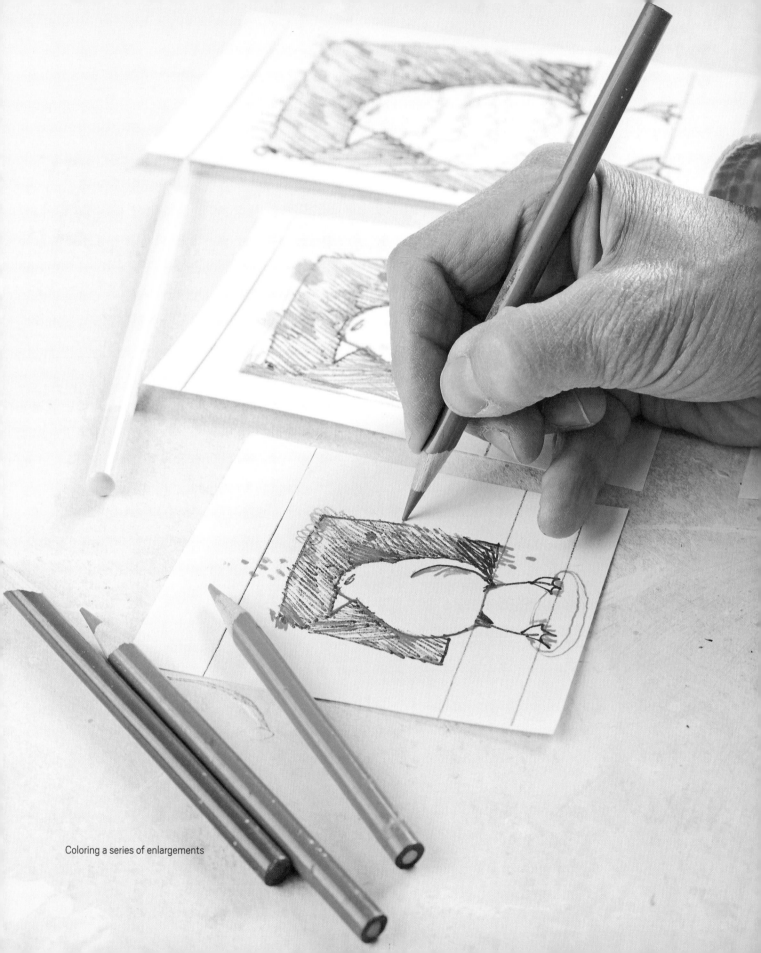

Coloring a series of enlargements

8 EXPANDING IMAGERY WITH A COPY OR SCAN

This technique of making a small doodle larger with a copy machine will help grow not only your artwork but also your imagination. It is often easier to make small pieces of art; it might be challenging at first to work larger. Seeing your small work become instantly larger via photocopy can help transition you into creating larger pieces.

GET STARTED

Start with doodles approximately 1" to 3" (2.5 to 7.5 cm) in size. Doodles are easier to enlarge if what you start with is small.

To photocopy, place your image on the copy machine glass and locate the zoom feature. Most machines can enlarge an original image up to 400 percent. To scan and print, prepare your printer and scan your image; then use the zoom feature to enlarge or edit the image before printing. If you do not have a way to make photocopies or scans at home, you can work at your local print shop or library. Enlarge your doodles to three different sizes, such as 200 percent, 300 percent, and 400 percent.

TAKING IT FURTHER

The copy machine offers quick technical assistance with copying and enlarging your work. Make more copies of the image and present them in a repeated arrangement, perhaps composed in a pattern. Also try the reverse by taking a large image and making it smaller. Discover how a design can change, but yet be the same, when shrunk to a smaller format.

MATERIALS

small doodles, no larger than 3" (7.5 cm)

—

copy machine or scanner and printer

TECH TIP

Use a smartphone camera in edit mode to expand, crop, and further redesign your doodles. Play with color filters for a variety of effects. Taking advantage of this technology can open up new ways to transform your doodles.

BIRD: This original doodle bird measured 2" x ¾" (5 x 2 cm). Using a printer, it was easy to blow up within the size of the 8½" x 11" (21.6 x 28 cm) paper.

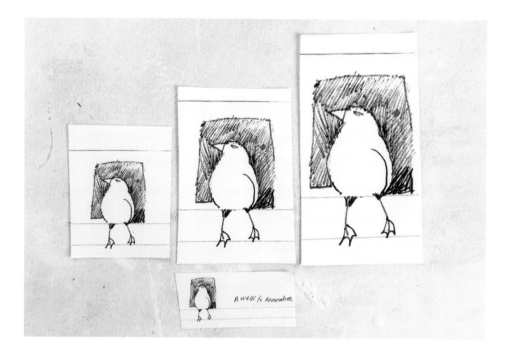

Original bird doodle at bottom. From left to right above, 200 percent, 300 percent, and 400 percent enlargements.

TREE: The original tree doodle was about the same size as the bird, but because it has more space between the lines, this one has more forms in the composition.

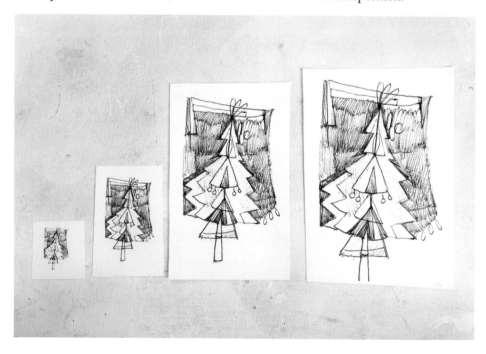

From left to right, original tree doodle, followed by 200 percent, 300 percent, and 400 percent enlargements

EXERCISE

9 ADDING COLOR

After blowing up your small doodles, it's time to add color from warm, cool, and gray palettes.

GET STARTED

Divide the colored pencils among warm, cool, and gray tones. Warm colors are the colors of the sun: yellows, reds, and oranges. Cool colors are those of the ocean: blues, greens, and purples. Grays are more neutral in tone: think of a gray day when the sun is not shining and colors are not as intensely saturated. Use the cool colors on the first enlarged image, the gray colors on the second image, and the warm colors on the third image. Observe how using different color families on the same image changes its presence. Which one do you like best? Figure out why, as it can inform your color selections when you paint.

MATERIALS

colored pencils

—

doodles, enlarged
to small, medium,
and large

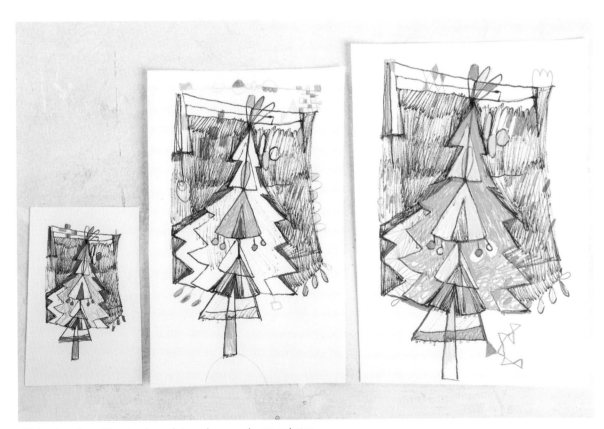

All sizes together, with colored pencils in cool, gray, and warm palettes

Enlarge more images in various sizes and use other color combinations. Mix up the cool colors and warm colors on one image, or try using only complementary colors—colors that are opposite one another on the color wheel (green and red, blue and orange, or yellow and purple). Try analogous colors, groups of three colors that are next to one another on the color wheel, such as red, orange, and yellow or blue, green, and yellow. Try other combinations. There are endless exciting possibilities.

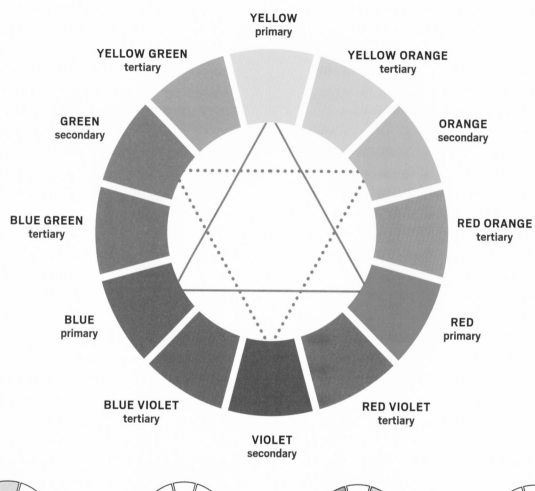

PRIMARY
yellow
red
blue

SECONDARY
orange
violet
green

TERTIARY
yellow orange
red orange
red violet
blue violet
blue green
yellow green

ANALOGOUS
three color that are
next to each other on
the color wheel

CREATING A FINAL PRESENTATION

After filling in your enlarged doodles with colored pencils, mount the images on colored cardstock for a final presentation.

Measure and mark the placement of each of your enlarged doodles on its own sheet of cardstock, which will become the background. Attach it using a glue stick or double-sided tape. This presentation gives your work significance: the cardstock provides a home for your doodle and ups the level of the work.

Put the mounted work in a frame. The cardstock acts as a mat around the image and is perfect for displaying a final framed piece of artwork. You could also make greeting cards by printing the same image repeatedly and mounting each copy on a blank notecard.

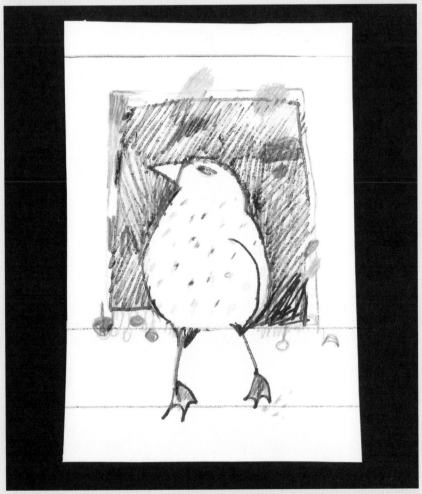

Gray palette on black cardstock

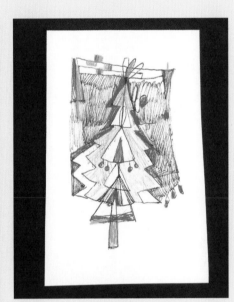

Cool palette on black cardstock

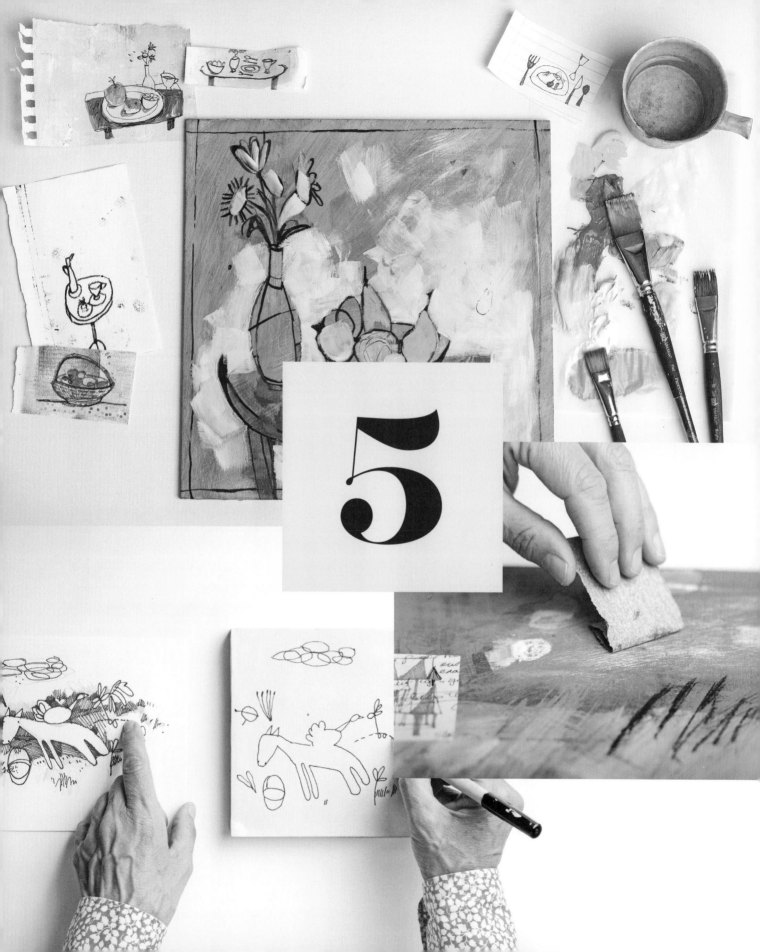

5

MIXED MEDIA

Painting with Your Doodles

In this chapter, we will take your collected treasures and turn them into a painting. The previous chapters have led us here, helping us transition with gradual momentum from the small, intimate doodle to the precursors of a large painting. The foundation is still in the doodle—finding creative flow without a preconceived idea of the imagery to be created. In painting, the flow is the same. Trust the process as you add layers of paint. Find joy in the making.

3 COPY YOURSELF: HAND-EYE COORDINATION

PROJECT

This method is another way of expanding your doodles, by copying them without using a printer or copy machine. We will be using the physical coordination of the left and right hands, echoing their movements. Your non-dominant hand is on the doodle, and your dominant hand holds a marker to "copy" the image onto the painting surface. This creates a new image from the guidelines that already exist in your doodle. To preserve the feeling of making marks on paper, we will glue rice paper to a wood panel. The rice paper absorbs the acrylic paints and translates to a softer look and feel.

GET STARTED

Select a larger doodle image that you want to duplicate, about 5" (13 cm) across. Apply gesso to the wood panel if it has not already been gessoed. Let it dry and then glue down the rice paper. I use gel medium, which works like glue, to attach the rice paper. Lay the paper onto the surface and then apply the medium to the top of the rice paper, spreading it out from the center for less wrinkling. The medium will completely saturate the paper and adhere it to the surface. Let dry. Trace the doodle with the pointer finger of your non-dominant hand, and with your dominant hand, use a marker to simultaneously recreate the image on the rice paper.

MATERIALS

doodle to copy

—

6" x 6" (15 x 15 cm)
wood panel

—

gel medium,
gloss or matte

—

Okawara rice paper

—

black ultra–fine
tip marker

—

paintbrushes

—

acrylic paints
(I used cadmium yellow
hue, Jenkins green,
cobalt blue, titan buff,
and titanium white)

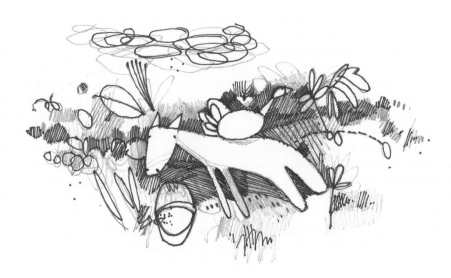

Doodle image

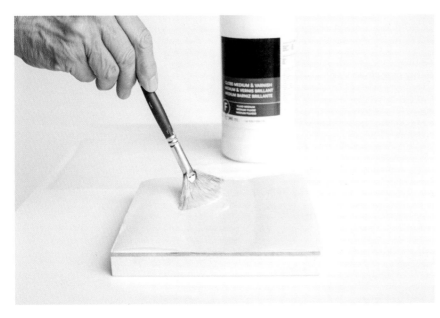

Gluing down the rice paper

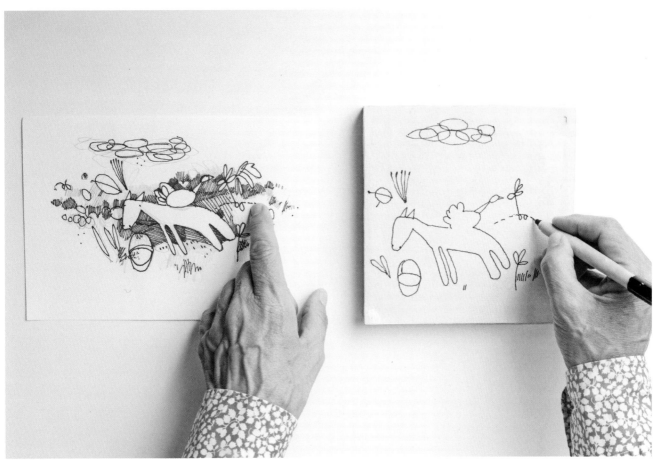

Left and right hands tracing the lines together

TAKING IT FURTHER

Now color in your doodle with acrylic paints. If you would like, you can create a test color palette in advance. Get inspiration for your color scheme from another painting, from fashion or décor magazines, or choose your favorite combinations. For depth, be sure to use both light and dark colors. If you would like, incorporate some complementary colors (blue and orange, red and green, or yellow and purple) for contrast and liveliness.

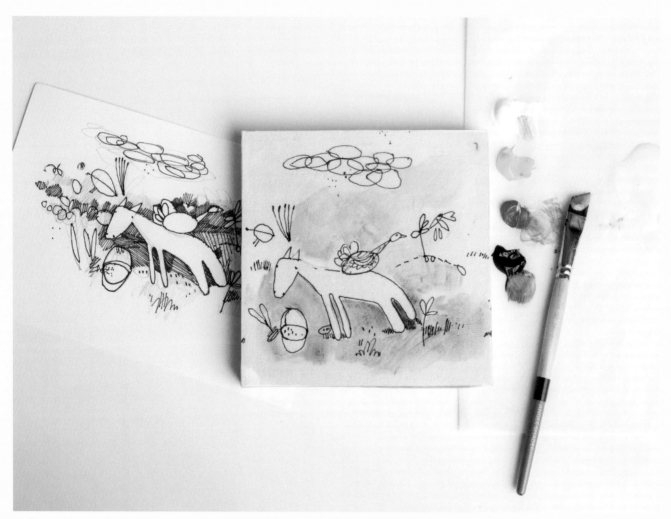

Applying paint

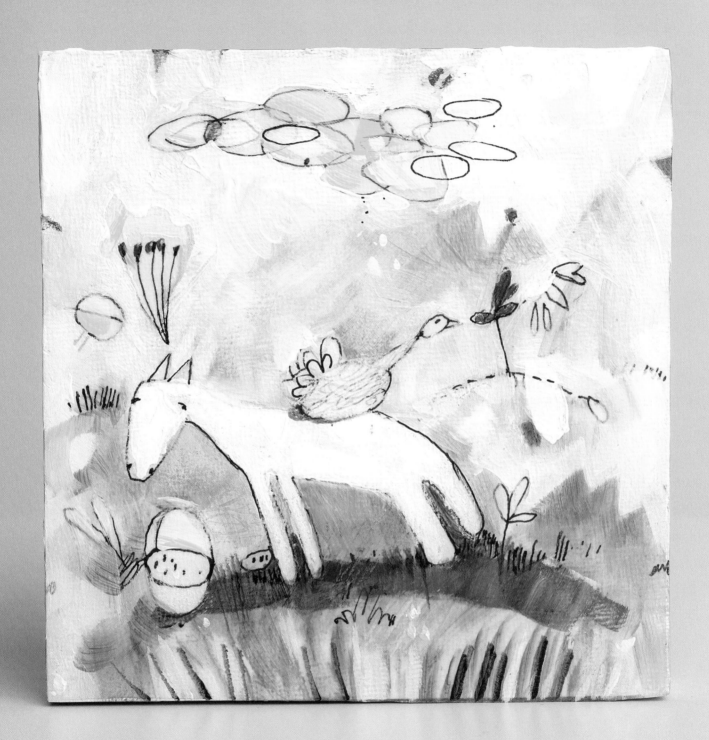

The final image

4 GRID PAINTING

Grids are everywhere once you start noticing them—in a city, with its buildings, windows, sidewalks, and streets, or in the country, with its fields, tree lines, crop rows, and fences. Thinking and seeing in grids will make you more aware of other design qualities in your environment. A grid can be used to organize the composition of a work, by placing various-size boxes next to one another with doodles inside each. A grid is an excellent way to organize your doodles on canvas.

You can measure a grid with a ruler to make equal spaces. I lay it out by hand, unmeasured and unconfined, which gives me freedom to invent as the composition forms. The grid creates boxes that will hold the doodles inside, like they are being hugged within that space. The doodles can also extend into other blocks, connecting them in new and inventive ways. Your grid can also be puzzle-like, with interconnecting shapes that are square, oblong, rectangular, or organic and in all different sizes.

GET STARTED

Glue the rice paper to the canvas with gel medium and let dry. Glue from the center out for less wrinkling. The rice paper will absorb the script brush line as well as the acrylic paints, creating a beautifully smooth surface. Next, choose a warm acrylic paint color for your first layer and apply it with a large brush. Then, with a script brush, make a grid of three vertical lines and two horizontal lines for a grid of twelve boxes. Choose doodle images that you would like to transfer to the canvas. Using a script brush will form a line similar to how a marker would recreate the images from your doodles.

MATERIALS

Okawara rice paper

—

16" x 20"
(40 x 50 cm) canvas

—

gel medium,
gloss or matte

—

large paintbrush

—

acrylic paints

—

script brush

—

flat brushes

—

collection of
doodle images

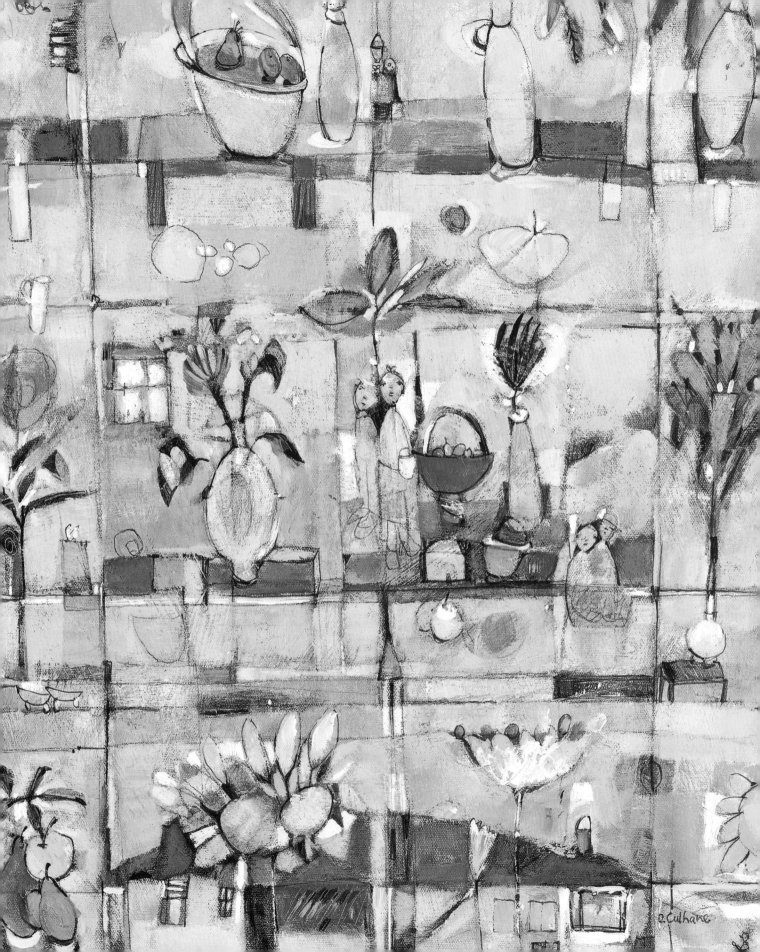

Covering the surface with a beginning layer of yellow paint

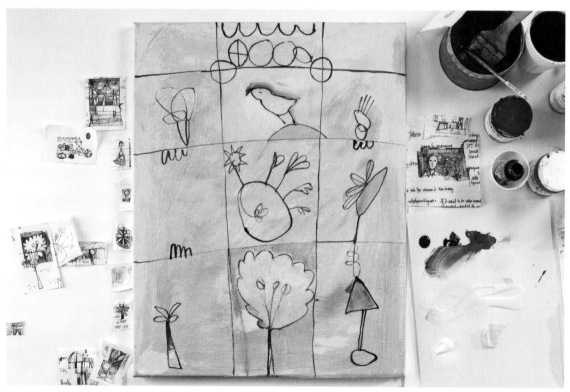

Drawing out the painting with the script brush

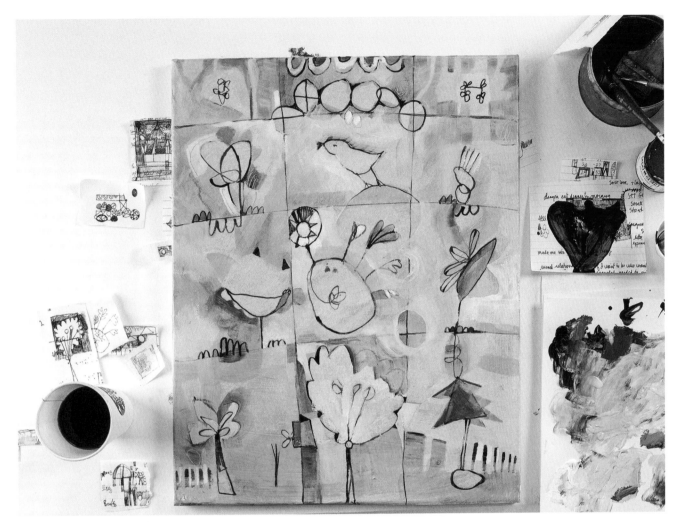
Finishing the painting to completion

TAKING IT FURTHER

Use a flat brush to fill the grid composition in with acrylic paint in any color you choose. I use the gel medium as an extender when I paint. It thins out the paint and adds a glaze of layers to the surface. When your painting is complete, go over it with a thin layer of gel medium. This seals and protects the surface of the painting.

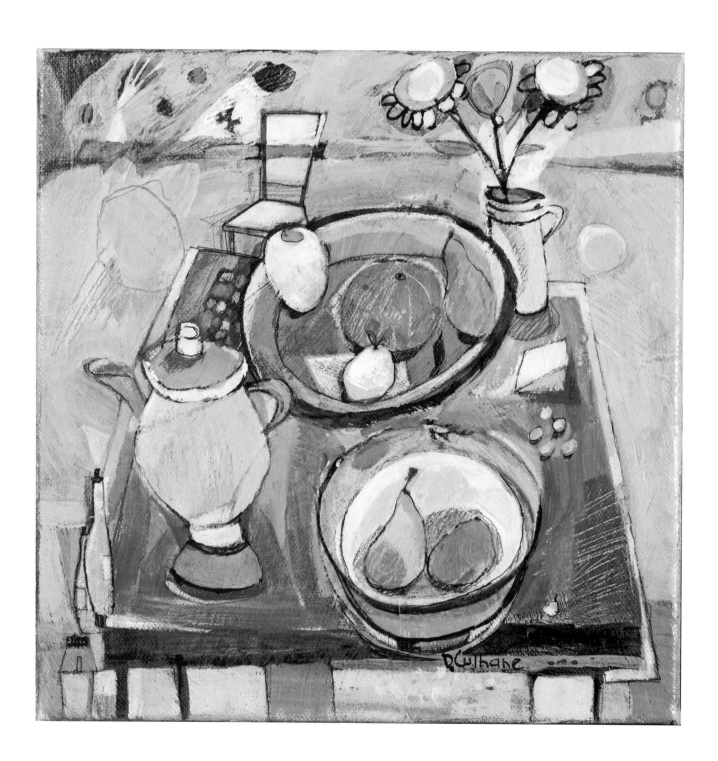

PROJECT 5 THEME PAINTING

Theme paintings are in the same category as exercise 6 (see page 42), where we saw that a concrete direction can help move the design process along. Choose a theme that excites you, something that makes you light up and really resonates with you. Select something that you feel passionate about or that speaks to your soul or that moves you when you are in the midst of creating. Remember to be open to possibilities and the process of your work as you go. A doodle is all about discovery, and so is this way of painting. It creates a place of strength from which to create.

For this project, I have chosen the theme of "still life." I love playing with images that are found in a traditional still life. I call these paintings *Table Tops*, because the shapes come from what we see on a table: dishes, flower vases, forks, knives, food on plates, and arrangements of fruit. This subject has endless creative possibilities, as we all gather around the table to connect with community, share food, and engage in conversation.

MATERIALS

12" x 12"
(30 x 30 cm)
wood panel

—

acrylic paints:
transparent red iron
oxide, Prussian blue hue,
cerulean blue chromium,
green gold, cadmium
yellow light, titanium
white, and titan buff

—

doodles

—

paintbrushes in
various sizes

—

gel medium

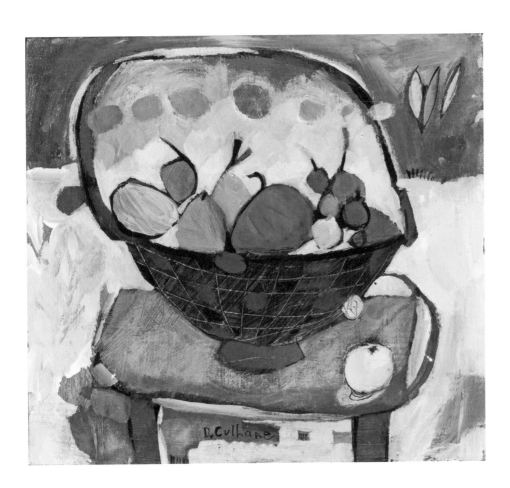

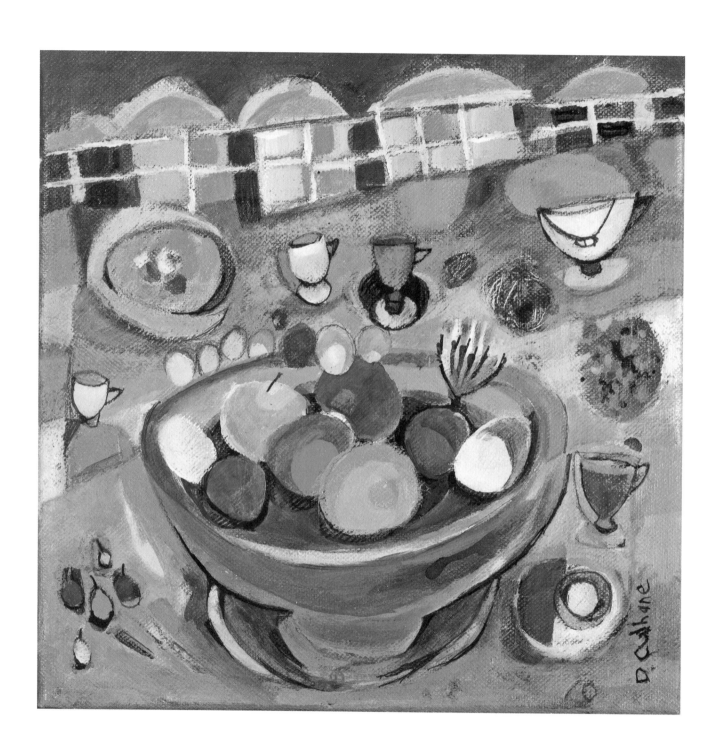

IF YOU CAN DOODLE, YOU CAN PAINT

GET STARTED

Cover the wood panel with a layer of acrylic paint. I have chosen transparent red iron oxide. Gather your theme doodles all around you. Outline your images with a script brush. I used Prussian blue hue to apply the paint with my script brush. Next, add other colors of acrylic paint. I mix the gel medium in with the paint. This adds shine to the layers of paint and creates a glazed, transparent effect.

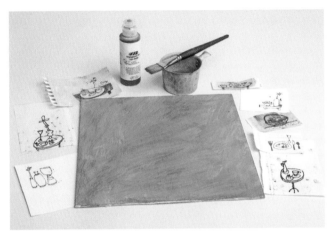

Applying the first layer of transparent red iron oxide

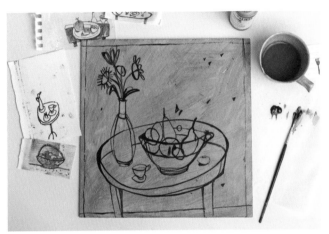

Using Prussian blue hue to outline the forms

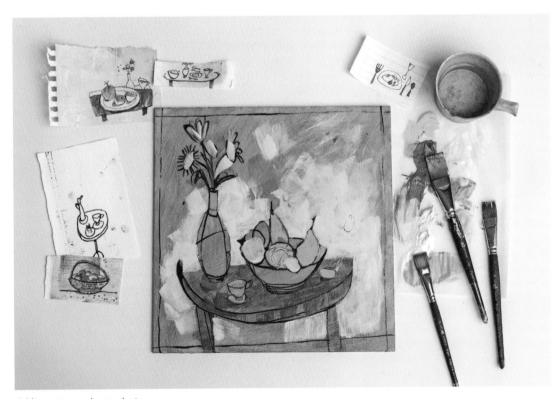

Adding various colors to the images

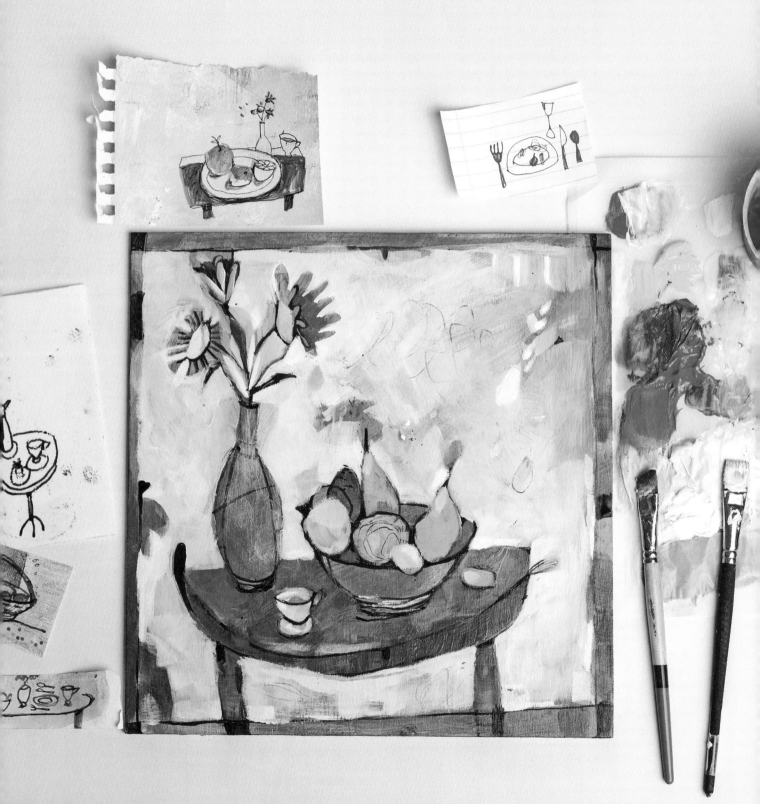

The completed painting

TAKING IT FURTHER

Whatever theme you choose—whether birds, bikes, trees, boats, or something else—take on the challenge of working on more than one painting at a time. Try working on three or more paintings to create a moving dialogue. Make paintings on the same theme on the same size wood panel or canvas. As the paintings develop together, they will dialogue with one another. They might even end up being a body of work or a series. I work on five to eight paintings at a time, because this keeps me from overthinking and overfocusing on just one. It also lets innovation flow more easily.

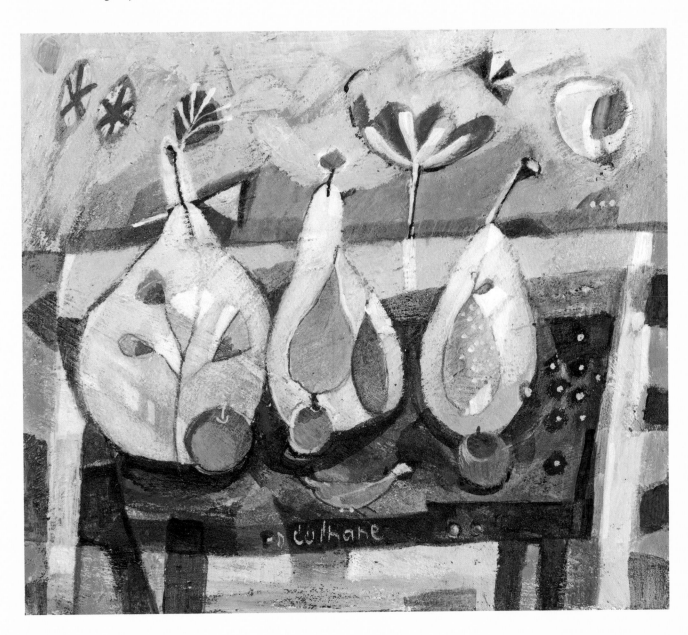

6 ABSTRACT PAINTING: MIXED MEDIA

Abstract art is all about mark making. It is a visual language dealing with elements of shape, form, line, color, and texture. Abstract art is an excellent way to discover your own visual language. In this abstract painting, we will use mixed media—crayons, oil pastels, charcoal pencils, and collage—to bring more possibilities to the creative work.

MATERIALS

acrylic paints: cadmium yellow hue, manganese blue hue, pyrrole orange, violet oxide, titan buff, and titanium white

—

paintbrushes

—

18" x 18" (46 x 46 cm) wood panel

—

crayons

—

oil pastels

—

charcoal pencils

—

collage papers

—

sandpaper

—

paint scraper

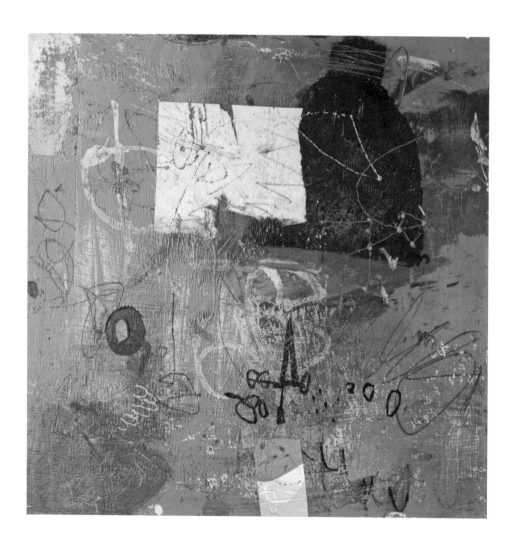

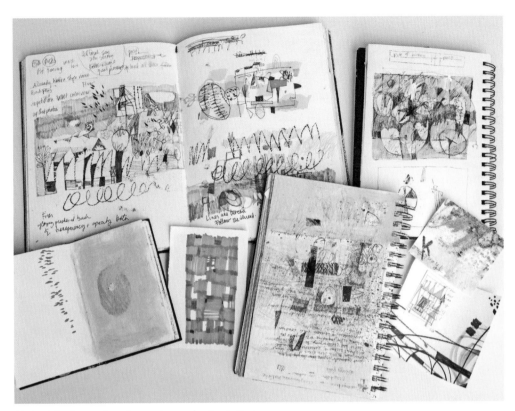

Abstract doodles can be referenced or used as inspiration.

Large butcher paper

GET STARTED

Apply layers of acrylic paint to your wood panel, then add geometric and organic forms. Think about angles and lines and how they intersect with the forms you painted. Add more layers: crayons, oil pastels, charcoal, and collage paper. Define values of the colors by pushing and pulling lights and darks.

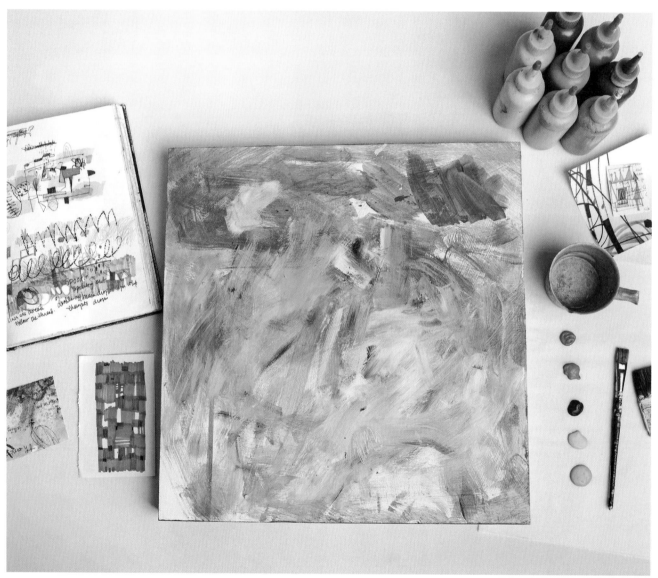

First layer of paint

IF YOU CAN DOODLE, YOU CAN PAINT

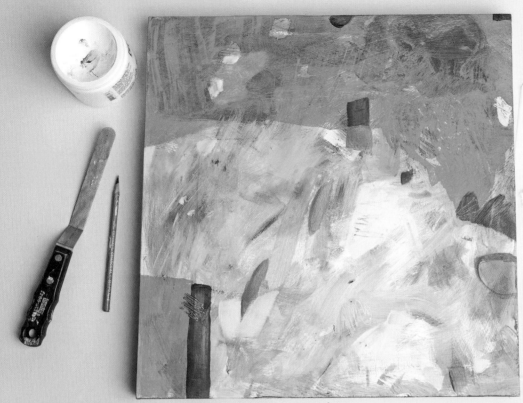

Second layer of paint

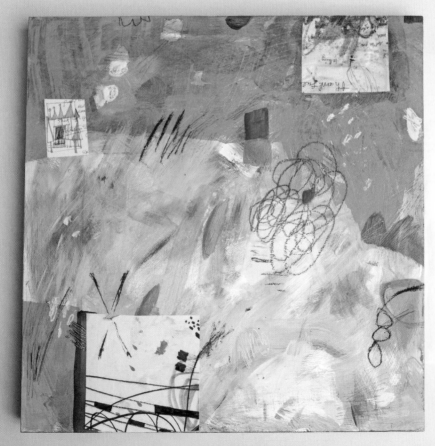

Adding mixed media:
crayons, oil pastels, charcoal,
and collage papers

TAKING IT FURTHER

To add variety, use large and small hand and arm movements while painting. For visual interest, use sandpaper and a paint scraper to rough up the surface, which adds texture and exposes layers underneath.

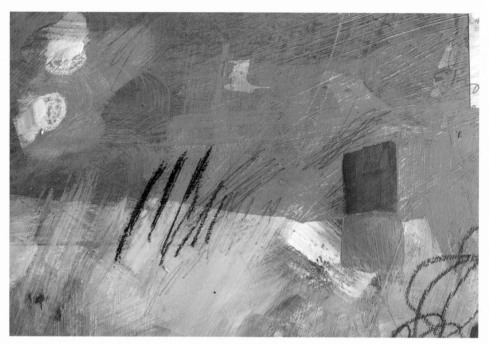

Close-up of painting

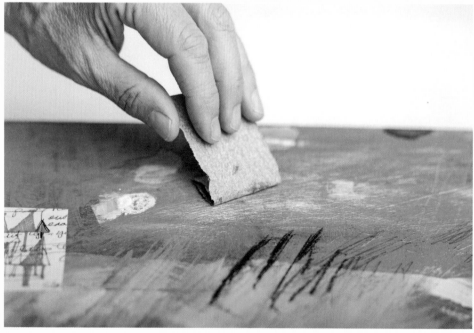

Sanded area

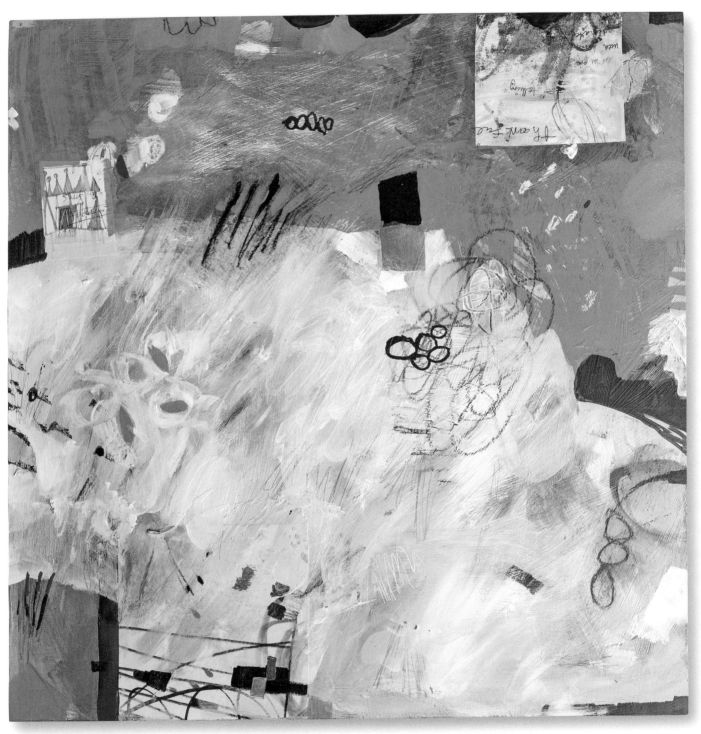

Final work

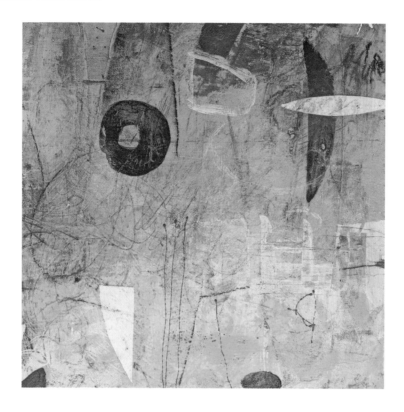

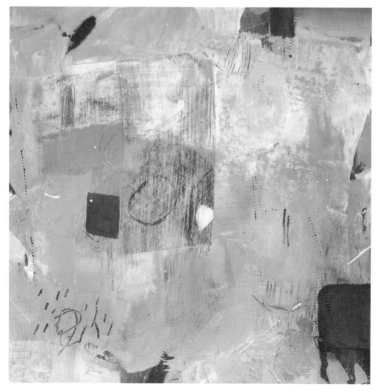

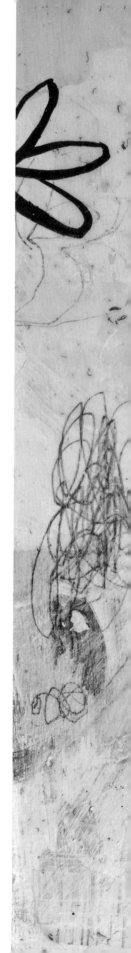

IF YOU CAN DOODLE, YOU CAN PAINT

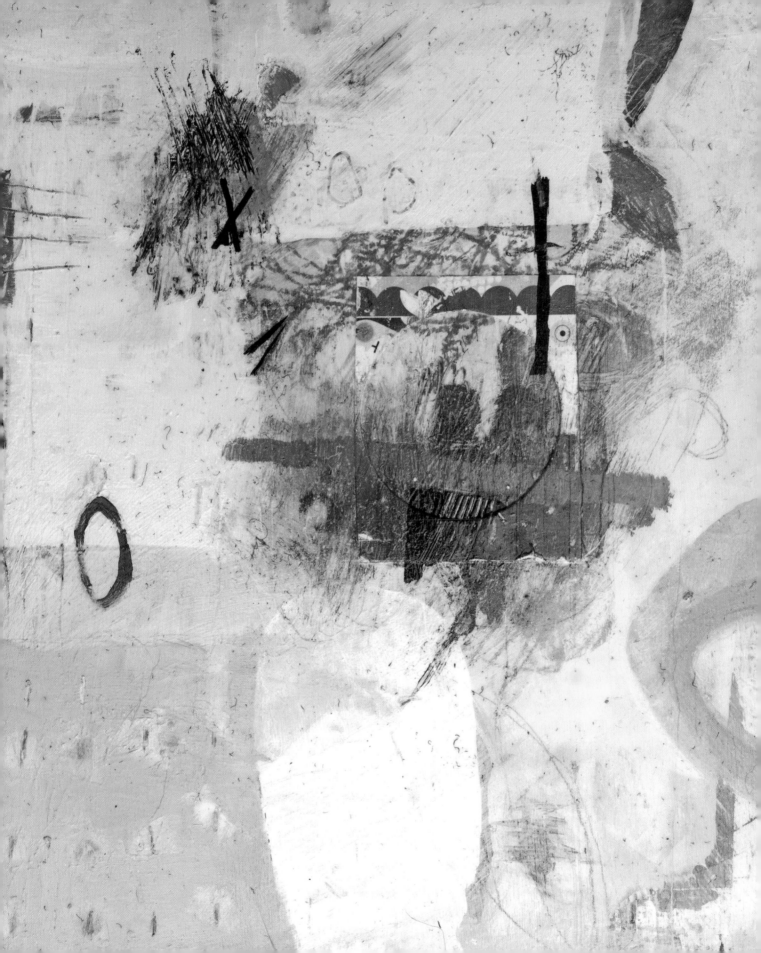

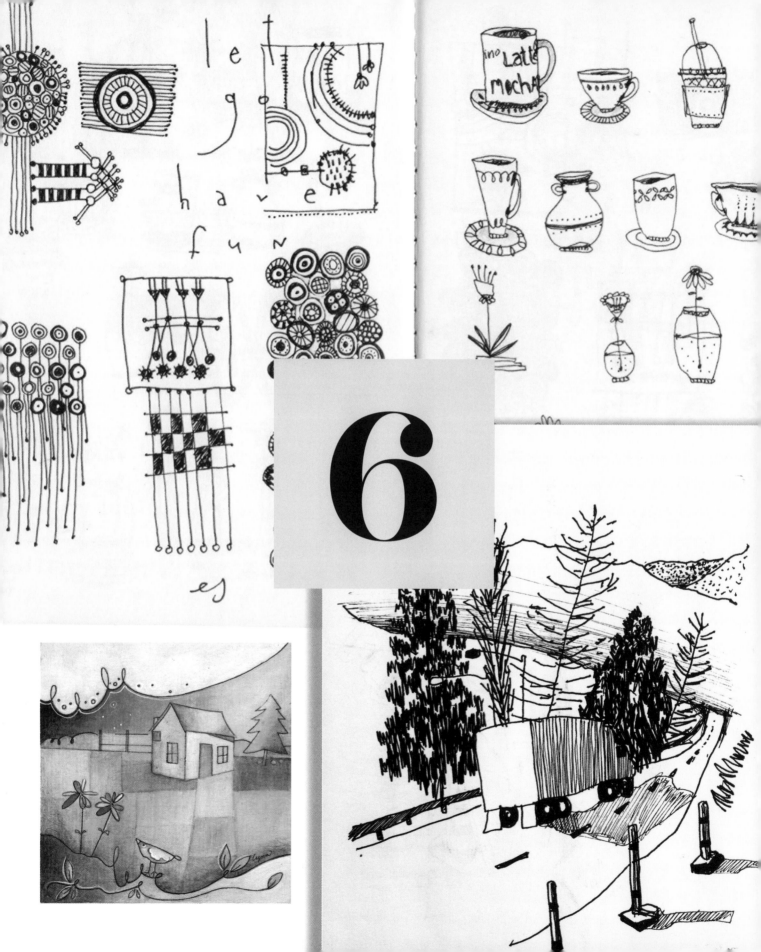

let

g

have

fun

es

Latte
Mocha

6

ARTIST GALLERY

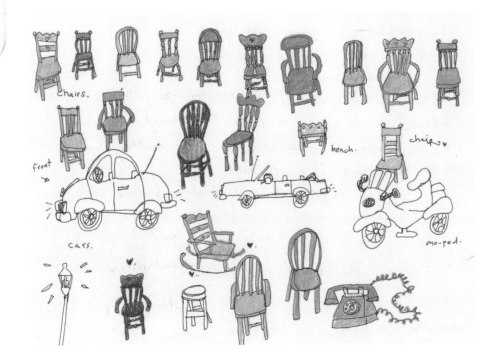

chairs.

front

cars.

bench.

chairs

mo-ped.

LISA FIRKE

Lisa Firke makes art in a handmade house in Princeton, New Jersey. You can find her on the web at www.lisafirke.com.

Little Houses/Doodle Cottages
An assortment of tiny house doodles, auditioning for attention within a larger piece of art. Micron pen on scraps of paper.

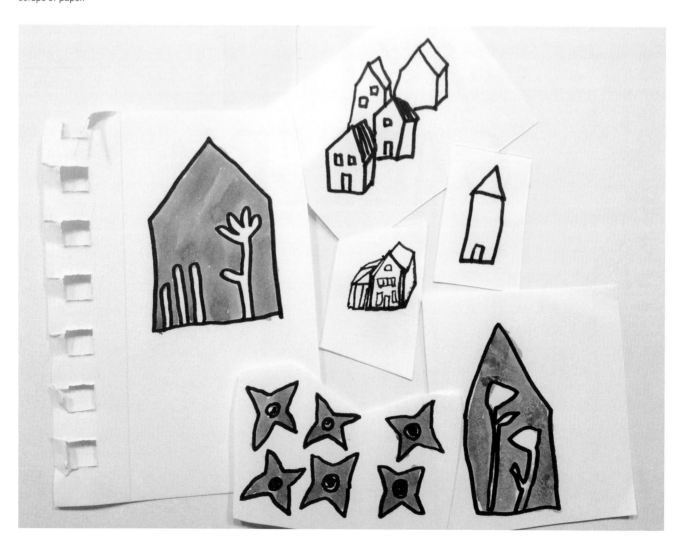

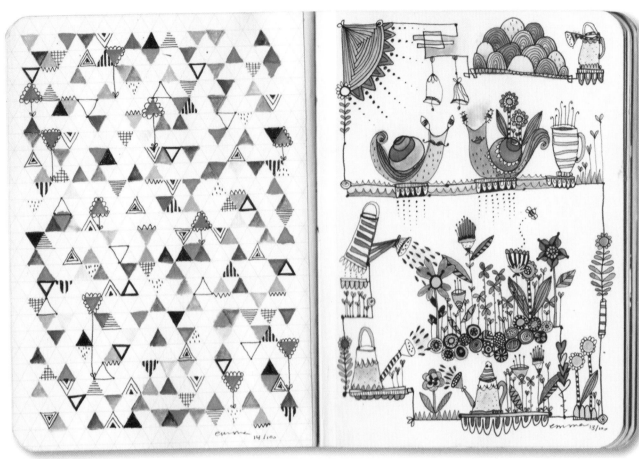

EMMA SCHONENBERG

Emma Schonenberg is a passionate surface designer who hails from El Salvador. Along her journey, she discovered her true passion in surface pattern design. After much research and development, she mustered up the courage to travel the world to exhibit at trade shows. She has since flourished and is known for her signature kaleidoscope style enhanced by original photos she takes during her travels. Find her on Instagram @Emma_Schonenberg

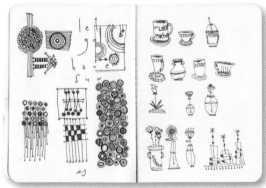

Flower Bouquet
These images are a journey . . . exploring . . . and one thing leads to another. Everything is connected.

A & L Go on an Adventure
This piece was created on a flight from Pittsburgh to San Diego on July 4, when two women in their late forties decided to rekindle a childhood friendship that started in 1977. They began an epic journey covering over 4,000 miles of air and driving time to kick off a year of living together to support each other during difficult times.

AMANDA SAINT CLAIRE

After retiring from a career as a lawyer, Amanda Saint Claire began painting at age forty-five. Much to her own surprise, it became immediately apparent that Amanda had uncovered her true calling, and she hasn't looked back. Amanda strives to create dynamic tension in her work through the use of color, composition, and layering, and her work is a reflection of her journey to be wholehearted and remain forever in childlike wonder. Amanda has lived on all three coasts of the United States and in Europe and Southeast Asia, and she has been a world traveler since the age of sixteen. She currently resides with her family in Del Mar, California. Visit her on the web at www.amandasaintclaire.com.

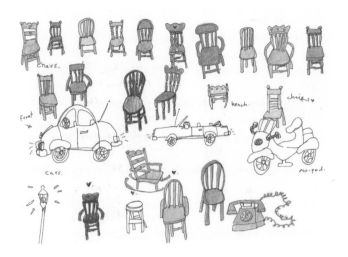

RACHEL BRIANNA LYNN

Rachel Brianna Lynn is a teacher, an illustrator, a lover of the outdoors, and a chronic doodler. She can be found either lost in a sketchbook with a pen in her hand in the small town of Hood River, Oregon, or snowboarding during the winter season on Mt. Hood. Rachel coaches snowboarding during the winter, is a full-time nanny year-round, and loves sharing her passion for doodling with children. Visit her on Instagram @rachel_drawz or on the web at www.sidewalksandsunsets.wordpress.com.

A Story of Chairs

These doodles were inspired by vintage chairs at the artist's grandmother's house. She says, "For me, a chair holds grace in the style and colors in which it is made. A chair is for resting, eating, writing, doodling . . . I was inspired to draw these chairs and give each one its own personality, character, and color."

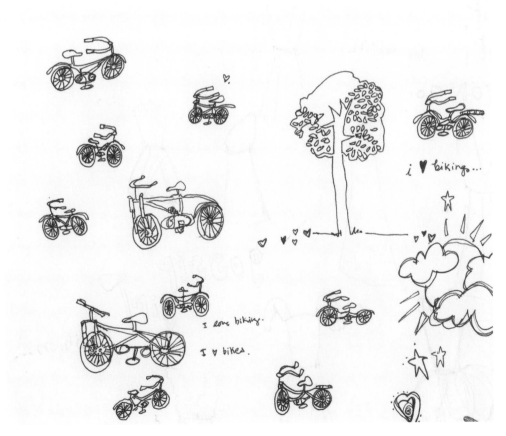

For the Love of Bikes

Growing up, riding a bike was very important in Rachel's daily life, whether it was biking around the neighborhood all day with her best friend or a mountain bike trip with her family. She says, "I believe that bikes are simple, romantic, and the perfect subject of a good doodle. Doodling bikes for me is a rhythm and I could doodle them all day."

LYNN YOKLEY

Lynn Yokley is a Michigan-based artist who is currently working to develop her skills as an illustrator. She enjoys challenging herself as an artist by learning new techniques. Contact her at lynnsbox@outlook.com.

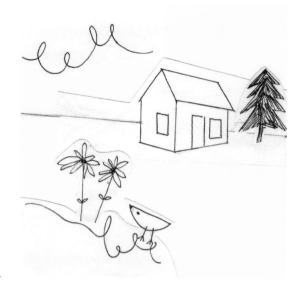

Dreaming of Home

The process of cutting up her doodles and then arranging them into a pleasing composition is a fun and delightful way for Lynn to work. She says, "It has opened my eyes to new possibilities and changed my approach when beginning a painting." Wood panel, Okawara rice paper, acrylic paints, pen.

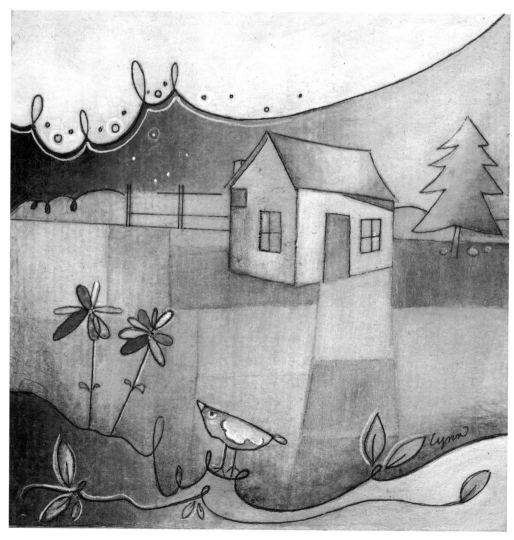

CAROLINE CLARK

Caroline Clark's earliest memories always involved imaginary worlds with unique friends and unusual adventures. She was continually creating games with elaborate components, making paper dollhouses, and sewing felt creatures. This love of making and the joy of learning led her to a career in graphic design. See more of her work on www.carolineclark.com.

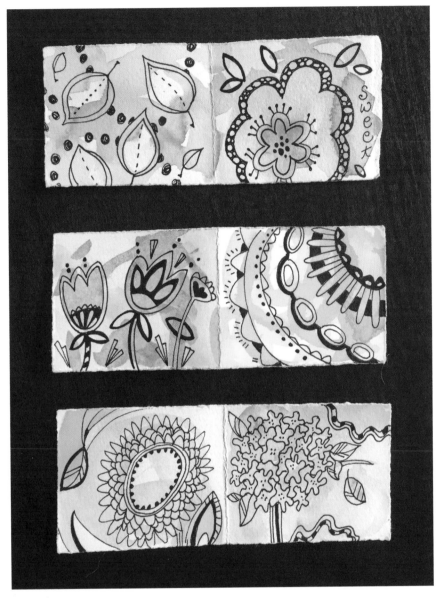

Doodle Warm Up 1
Doodles inspired by color, patterns, textures, and forms in nature. These pages were stitched together to create a mini book.

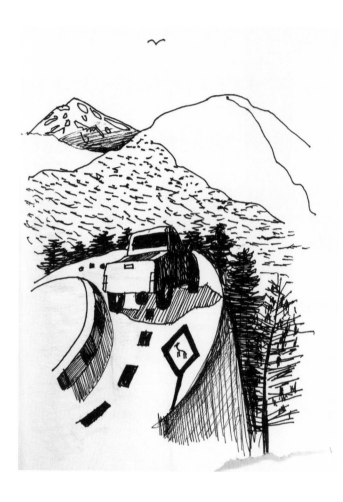

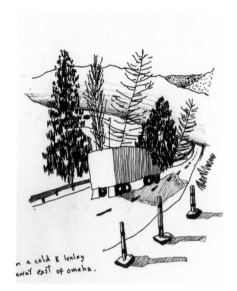

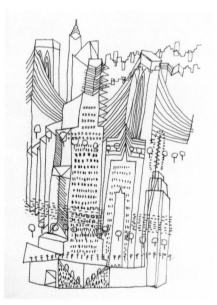

CHRISTOPHER BIBBY

Christopher Bibby's career as an artist began on the streets of Glasgow, Scotland, in 1997. He was a shy and skinny nineteen-year-old sleeping on the couch of his beloved sister Emma's home. While working in a coffee shop, a coworker saw his sketches and offered him a night job painting signs and graphics. Two weeks and some quick math later, Christopher quit his job to start a sign-writing company. Everyone thought he was mad, which, of course, he was. He began to teach himself the art of watercolors and attempted to support himself as a fine artist. It was during those bleak days in back alleys of Glasgow and Edinburgh that he found a passion for the beauty of the world and a commitment to creating honest, heartfelt, and meaningful art. Find him on the web at www.iambibby.com.

Cliff and *Truck & Road*

These little doodles were created in the passenger seat of a car on a road trip from Portland to California a few years back. The challenge was to sketch and doodle very quickly in order to capture the movement of the road and the changing landscape. The logging trucks, trees, sign posts, mountains, and the road itself became a wandering doodle storybook of the trip with old friend Robert Johnson.

Empire State

The architectural doodles are abstract geometric thought drawings of New York City taken from Christopher's imagination. These drawings later became larger paintings that now hang in a gallery in downtown Portland.

Logo Discovery

These are doodles that came out of a brainstorming exercise for a logo. Ben says, "It helps me to put down every idea that comes to mind, no matter how cheesy or bad they are. It clears them out of the way so there is room for further ideas to come up."

BEN WEILAND

Ben Weiland is a filmmaker and illustrator. He is founder of Arctic Surf, a creative endeavor to research waves along the coldest, most remote coastlines on the planet. Recently he's worked on assignment for *Surfer* magazine, directed a few adventure short films, art directed a product catalog, and illustrated two children's books. View more of his work at www.benweiland.com.

ABOUT THE AUTHOR

Diane Culhane is a ceramic artist, painter, and art educator who earned her B.F.A. from the University of Utah and her master's from Seattle University. She completed residencies at Anderson Ranch and Vermont Center for the Arts. Diane is represented by galleries and has sold her work nationwide. Her work is displayed in hospitals, restaurants, and libraries, as well as in the private collections of individual patrons and corporations.

During the summer, Diane dedicates her time to teaching children at Kelsey Creek Fine Art School, which she established in 1992. Diane has taught at Bellevue Arts Museum, Kirkland Arts Center, Pratt, and Seattle Pacific University, as well as workshops across the nation.

For Diane, it is ultimately all about the love of making and sharing art's creative processes and gifts through teaching and, most importantly, mentoring one-on-one.

Diane lives in West Seattle and paints out of her studio in Ballard, Washington. When she's not in the studio, she's gaining inspiration in nature while biking and hiking.

ACKNOWLEDGMENTS

Big huge thanks to all the people who showed me the way in my desire to be an artist.

To Mary Ann Hall, who believed in me. To my project manager, Meredith Quinn, my editor, Karen Levy, and my art director, David Martinell, for your steadfast guidance. Thank you to publisher Winnie Prentiss and all the wonderful people at Quarry Books.

Thank you to my photographer, Matisse Berthiaume, who brilliantly orchestrated the images in this book and for her devoted presence during this process.

Thank you to Steve and Carla Sonheim, for producing Doings of a Doodle, the online class that paved the way for this book.

Thanks to my mentor Nicholas Wilton. Thanks to my cheerleaders Alfonso Adinolfi, Amanda Saint Claire, Kim Morris, Sue Danielson, Lynn Whipple, Richard Kedwards, Joy and Richard McIlvaine, Suzi Johnson, Mary Iverson, Janet Weber, Layla, Marilyn Haygar, and Carolyn Seipe, for the many pep talks.

Deep gratitude to my beloved mom Virginia Culhane, my daughters Rachel and Jennifer, my son-in-law Ben, and to my family for their love and support along the way.

Finally, big hugs to my students and fellow artists for filling me up with their joyful companionship.

ALSO AVAILABLE

Cloud Sketching
978-1-63159-095-5

IlLISTration
978-1-63159-094-8

*Drawing Lab for
Mixed-Media Artists*
978-1-59253-613-9

*Change Your Life
One Doodle at
a Time*
978-1-63159-087-0

*20 Ways to Draw a Cat
and 44 Other
Awesome Animals*
978-1-59253-838-6

*20 Ways to Draw a
Doodle and 44 Other
Zigzags, Twirls, Spirals,
and Teardrops*
978-1-59253-924-6